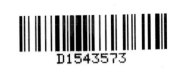

PHOTO ARCHIVE OF

FAMOUS PLACES OF THE WORLD

Donald M. Witte

DOVER PUBLICATIONS, INC.
New York

PUBLISHER'S NOTE

All the photographs in the present volume were taken by the eminent photographer Donald M. Witte on his global travels. Born in Aberdeen, South Dakota, he lived in the state of Washington from his childhood on. After attending the University of Washington, he joined the Army Signal Corps as a combat photographer in World War II.

Mr. Witte served in the South Pacific theater, assigned to the front lines, where he obtained some excellent invasion coverage. Among the earliest American troops to enter Japan, he was later official Signal Corps photographer for the surrender ceremony aboard the battleship *Missouri*.

After his discharge from the Army, Mr. Witte worked as a prominent commercial photographer in Seattle before founding Totem Press, which became noted for his calendar pictures. An avid world traveler all his life, he was an outstanding exponent of his craft, seldom allowing his favorite Rolleiflex or Hasselblad out of reach.

Sixty-one of Mr. Witte's view photographs were published in an edition of 100 copies offered as gifts to good customers of the Totem Press. Fifty-eight pictures from that publication (which was called *Treasures of the World*) appear again in the present Dover volume, along with an additional 64 images; all 122 views have been newly shot from vintage positive prints.

This Dover volume introduces a geographical arrangement (clearly outlined in the List of Photographs that follows this Note). All the text in the volume is new. The captions succinctly identify the building or other object depicted and its location, to the extent possible. The List of Photographs usually adds some further information, such as dates, architects of buildings, names of sculptors and the like.

Both man-made objects and natural wonders are featured in the views contained here. Many are truly world-famous and serve as emblems of their nations: the Parthenon, the Grand Canyon, the Eiffel Tower, the Houses of Parliament, the Great Sphinx, the Leaning Tower, Rio harbor and a goodly number of others. Some views show monuments and sites that may not be equally well known, but are of considerable historic importance; while a few show scenes that are not specific but are typical of their country or region. For those who have visited these places, for armchair travelers, or for advertisers and commercial artists who need these scenes for their assignments, this volume will be a handy and frequently consulted reference.

Copyright © 1993 by Mrs. Donald M. Witte.
All rights reserved under Pan American and International Copyright Conventions.

Published in Canada by General Publishing Company, Ltd., 30 Lesmill Road, Don Mills, Toronto, Ontario.

Published in the United Kingdom by Constable and Company, Ltd., 3 The Lanchesters, 162–164 Fulham Palace Road, London W6 9ER.

Photo Archive of Famous Places of the World is a new work, first published by Dover Publications, Inc., in 1993. Fifty-eight of the photographs herein were previously published in *Treasures of the World*, Totem Press, n.p. [Seattle], n.d. (edition of 100 copies offered gratis to customers). All text in the Dover edition is new and specially prepared.

DOVER *Pictorial Archive* SERIES

This book belongs to the Dover Pictorial Archive Series. You may use the designs and illustrations for graphics and crafts applications, free and without special permission, provided that you include no more than six in the same publication or project and credit the author, title and publisher of the book. (For permission for additional use, please write to Dover Publications, Inc., 31 East 2nd Street, Mineola, N.Y. 11501.)

However, republication or reproduction of any illustration by any other graphic service, whether it be in a book or in any other design resource, is strictly prohibited.

Manufactured in the United States of America
Dover Publications, Inc., 31 East 2nd Street, Mineola, N.Y. 11501

Library of Congress Cataloging-in-Publication Data

Witte, Donald M.
Photo archive of famous places of the world / Donald M. Witte.
 p. cm. — (Dover pictorial archive series)
ISBN 0-486-27496-9
1. Geography—Pictorial works. I. Title. II. Series.
G138.5.W58 1993
910'.22'2—dc20
 92-32419
 CIP

LIST OF PHOTOGRAPHS

38 Tower Bridge, London. Designed by Sir Horace Jones; completed 1894.

39 The White Tower, Tower of London. Begun 1078.

40 Westminster Abbey, London. Begun 1245, with additions up to 1890; numerous architects.

41 Hampton Court, near London. A residence of Henry VIII; built 1515–40, with later alterations.

42 Stonehenge, on Salisbury Plain. Constructed ca. 1850–1500 B.C.

43 The Roman baths (dating from the 1st to the 4th centuries A.D.) and the abbey church (begun 1499).

44 Anne Hathaway's Cottage, near Stratford-upon-Avon. 16th century.

45 Old St. Michael's Cathedral, Coventry. Built 14th century, bombed 1940.

46 Parish church incorporating a Norman tower.

SCOTLAND

47 "Jarlshof," Sumburgh, Shetland Islands. The "Jarlshof" ruins date from the Bronze Age through the 17th century A.D.

NETHERLANDS

48 A typical windmill.

49 The town hall, Gouda. Begun 1449.

FRANCE

50 The Sacré-Coeur Basilica, Montmartre, Paris. Designed by Paul Abadie; built 1876–1919.

51 The Eiffel Tower, Paris. Built by Gustave Eiffel for the 1889 World's Fair.

52 Notre-Dame Cathedral, Paris. Built 1163–ca. 1350.

53 Mont-Saint-Michel, off the coast of Normandy. The abbey church contains structural elements dating from the 7th to the 19th centuries.

SPAIN

54 Moorish architecture, Granada.

55 Court of the Lions, Alhambra Palace, Granada. Begun 1377.

56 Cathedral and Giralda tower, Seville. Cathedral built chiefly ca. 1400–ca. 1500. The tower, built 1184–98, was a minaret of the mosque formerly on the site. The bellchamber and statue were added in 1568.

PORTUGAL

57 Abbey of Santa Maria da Vitória, Batalha. Late 14th to 16th centuries.

58 Tower of Belém, Lisbon. Built as a river fort in 1515.

59 A typical windmill.

GIBRALTAR

60 Gibraltar, a British colony since the 18th century.

ITALY

61 The Arch of Septimius Severus (built 203 A.D.) and the Roman Forum, Rome.

62 The Colosseum, Rome. Built 72–80 A.D.

63 Castel Sant'Angelo and Ponte Sant'Angelo, Rome. The Castello—originally the mausoleum of the Roman emperor Hadrian, consecrated 139 A.D.—was converted to a fortress in the Middle Ages. The bridge, completed in 134 A.D., has medieval, Renaissance and Baroque additions.

64 St. Peter's Basilica, Rome. Designed by Donato Bramante, Michelangelo Buonarroti and others; built ca. 1450–ca. 1620, with later additions. The piazza and colonnades, 1655–57, were designed by Gian Lorenzo Bernini.

65 The Duomo (Santa Maria del Fiore), Florence. Designed by Arnolfo di Cambio, Giotto, Filippo Brunelleschi and others; built 1294–1436 (facade 1875).

66 The House of the Faun, Pompeii. Built ca. 100 B.C.

67 The cathedral (begun 1063) and its bell tower (the Leaning Tower, built 1173–1350), Pisa.

NORWAY

68 The Fantoft stave church at Bergen. Built in the 12th century at Sogn; moved to Bergen 1883.

DENMARK

69 The Little Mermaid statue, Copenhagen. Designed by Edvard Eriksen, 1913.

FINLAND

70 Sibelius Monument, Helsinki. Designed by Eila Hiltunen, 1967.

GERMANY

71 Mouse Tower on the Rhine at Bingen. Originally built 1208–20; present structure dates from 1855.

72 Die Wies (Pilgrimage church of Christ Scourged), Wies/Steingaden, Bavaria. Designed by Dominikus Zimmermann; begun 1746. Dome fresco by Johann Baptist Zimmermann, the architect's brother.

73 The town hall (Rathaus), Munich. Designed by Georg Josef von Hauberisser; built 1867–1908.

74 Neuschwanstein Castle, Bavaria. Designed for Ludwig II by Christian Jank; built 1869–86.

SWITZERLAND

75 The Château de Chillon, on the Lake of Geneva. Dates from the 13th century.

CZECHOSLOVAKIA (SLOVAKIA)

76 St. Michael's Tower, Bratislava. Lower part 14th century, upper part 1511–17, steeple 1758.

HUNGARY

77 The Fisherman's Bastion, Budapest. Designed by Frigyes Schulek; built at the turn of the 20th century.

GREECE

78 The Erechtheum, on the Acropolis, Athens. Late 5th century B.C.

79 The Parthenon, on the Acropolis, Athens. Designed by Ictinus and Phidias; begun ca. 450 B.C.

80 Theater, Delphi. Built 4th century B.C.

81 Typical windmills, island of Rhodes.

CYPRUS

82 Roman-era ruins at Salamis.

RUSSIA

83 Bell tower of Ivan III and the Tsar Bell, in the Kremlin, Moscow. Tower designed by Marco Bono; built 1505–08; later additions in 1600. Central building (belfry) designed by Petrok Malyy; built 1532–43. Annex (at right) originally built 1624; rebuilt early 19th century by I. V. Yegotov and L. Rusca. Bell cast 1735.

84 Church of the Resurrection of Christ, St. Petersburg. Designed by I. V. Malyshev and A. A. Parland; built 1887–1907.

NORTH AFRICA AND THE NEAR EAST

MOROCCO

85 Mausoleum of King Mohammed V, Rabat. Completed 1971, ten years after the King's death.

86 Minaret of the Koutoubia Mosque, Marrakesh. Built in the 12th century.

87 A medieval gateway.

EGYPT

88 The Great Sphinx and the Pyramid of Cheops, Giza, outside Cairo. Built ca. 2600 B.C.

89 The alabaster Sphinx at Memphis. Probably made between 1600 and 1200 B.C.

90 Ancient architectural elements.

91 Detail of the temple complex at Karnak, outside Luxor. Periods of construction extend from ca. 2000 to ca. 30 B.C.

92 The "Colossi of Memnon," Thebes, near Luxor. Statues of pharaoh Amenhotep III (ca. 1400 B.C.)

93 Detail of the temple complex at Karnak, outside Luxor.

LEBANON

94 The harbor in the medieval section of Byblos (Jbail).

TURKEY

95 A modern view near the ancient ruins of Ephesus (Efes).

96 The Temple of Hadrian, Ephesus. Built in the first half of the 2nd century A.D.

97 The fortress Rumeli Hisari, on the western shore of the Bosphorus, near Istanbul. Built 1452.

98 The Blue Mosque (Ahmet I Camii), Istanbul. Designed by Mehmet Aga; built 1609–16.

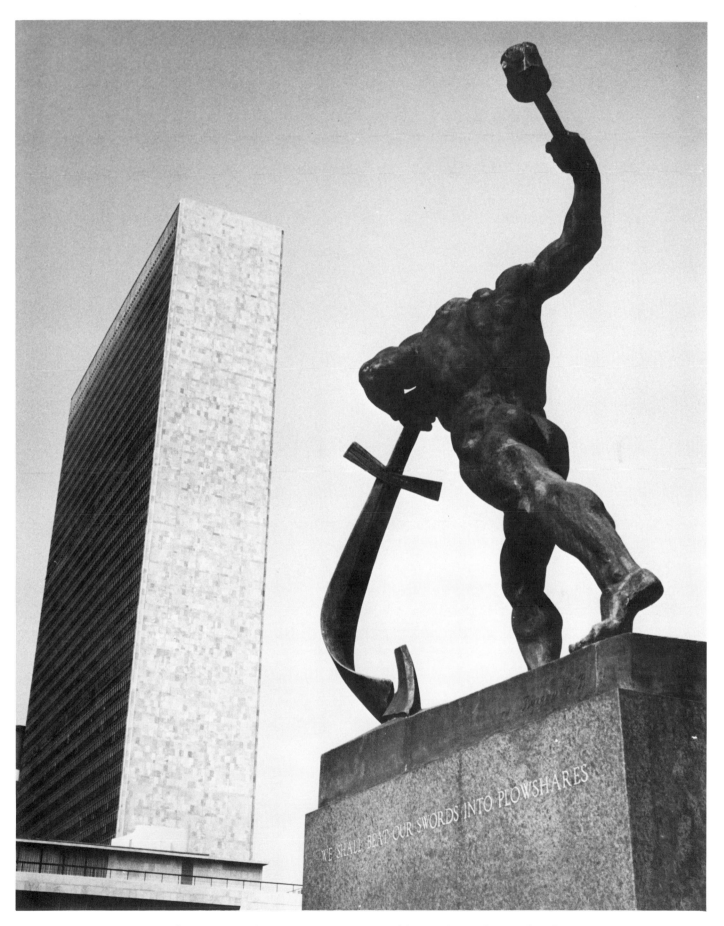

1 New York City: United Nations. Secretariat Building and *Swords into Plowshares* statue.

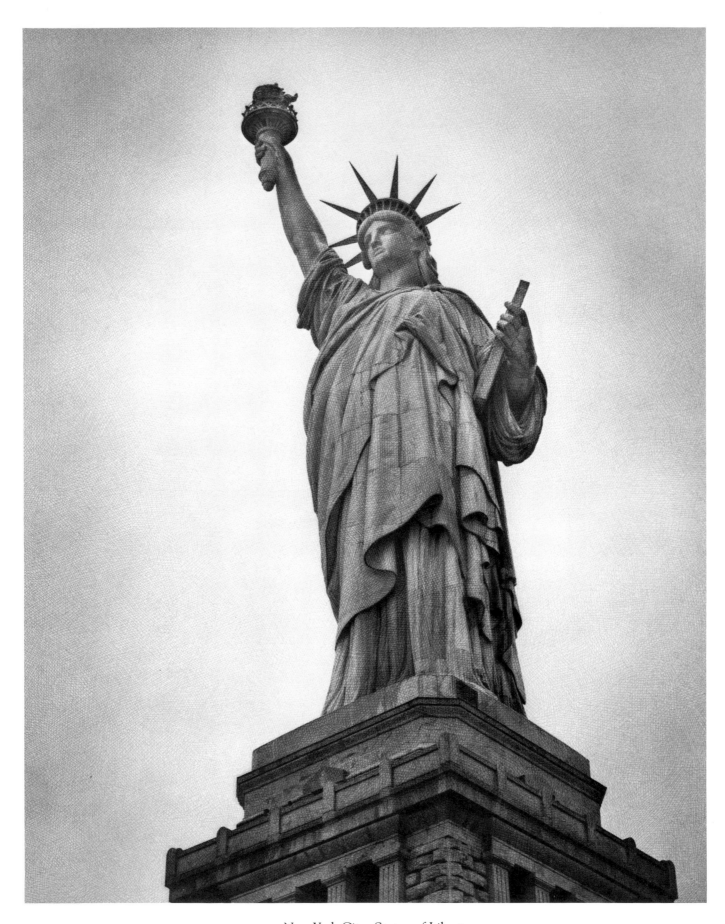

2 New York City: Statue of Liberty.

3 Washington, D.C.: Washington Monument.

4 Washington, D.C.: Jefferson Memorial.

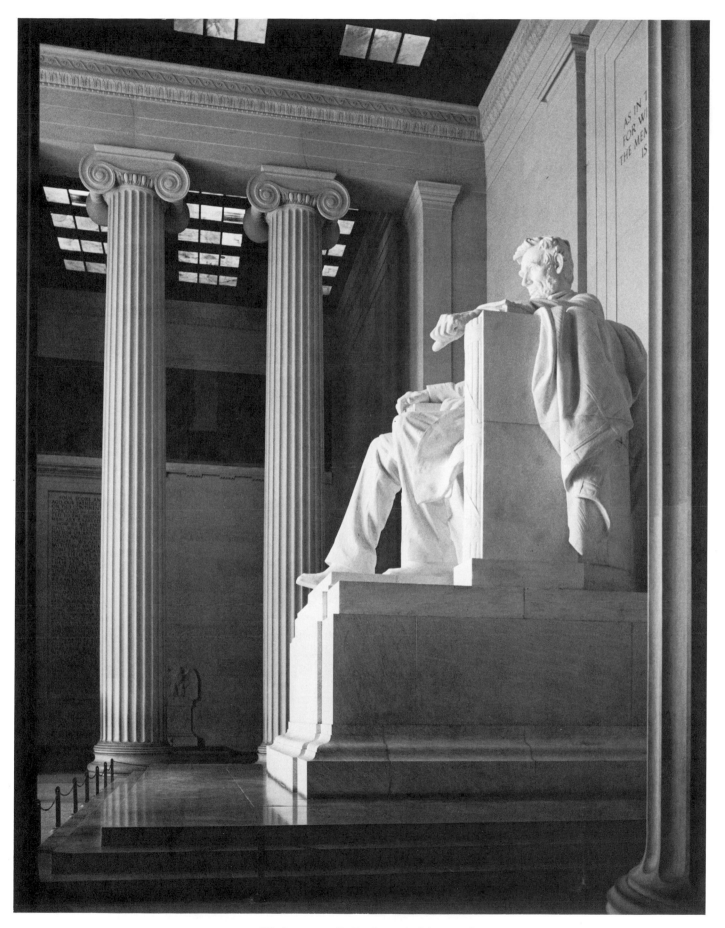

5 Washington, D.C.: Lincoln Memorial.

6 Virginia: Mount Vernon.

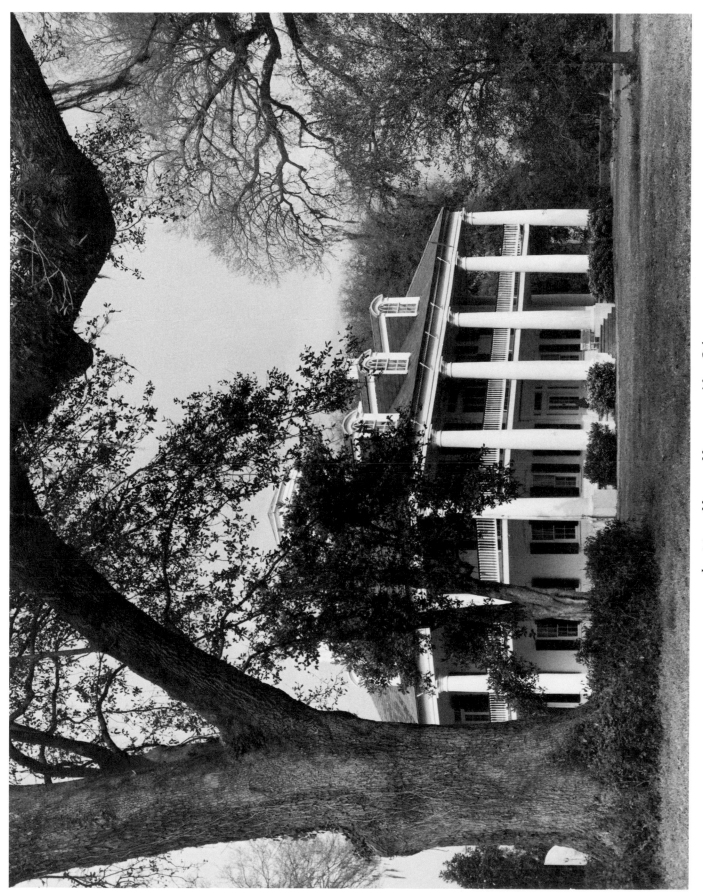

7 Louisiana: Houmas House, near New Orleans.

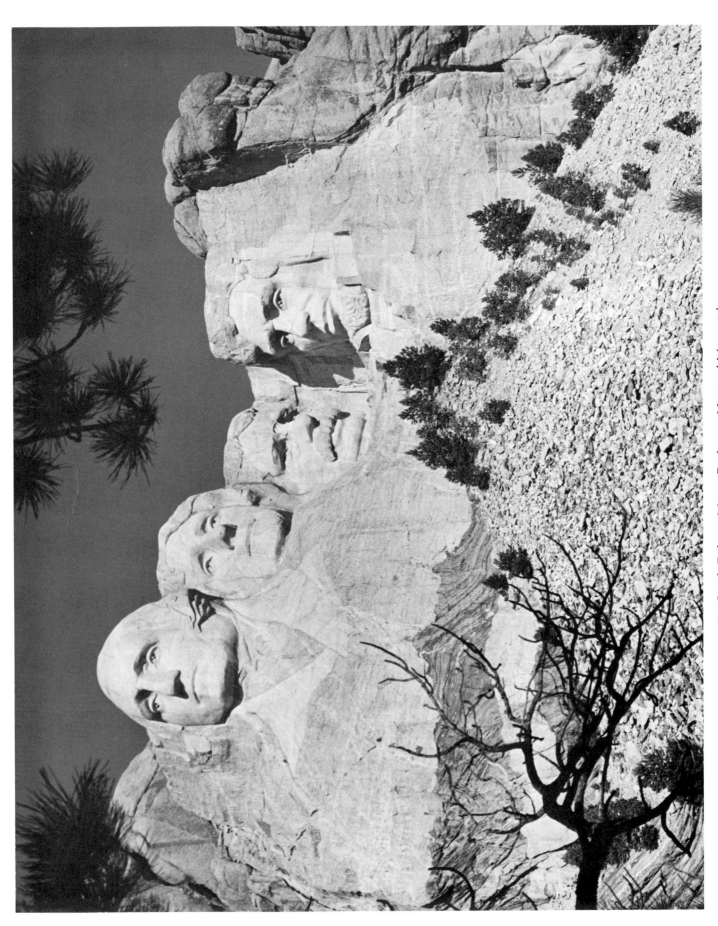

8 South Dakota: Mount Rushmore National Memorial.

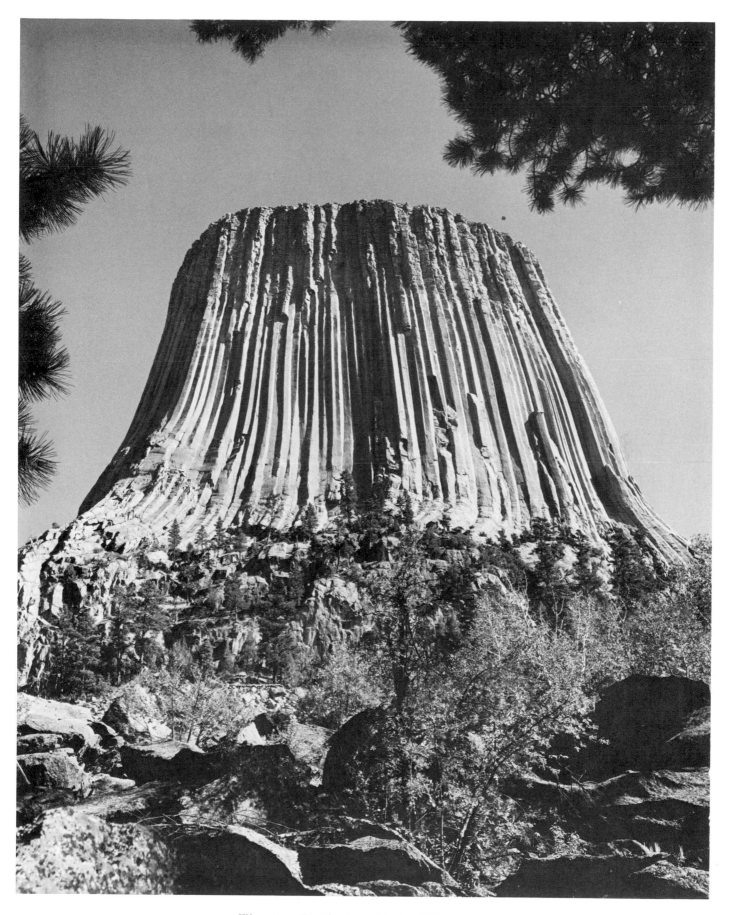

9 Wyoming: Devils Tower National Monument.

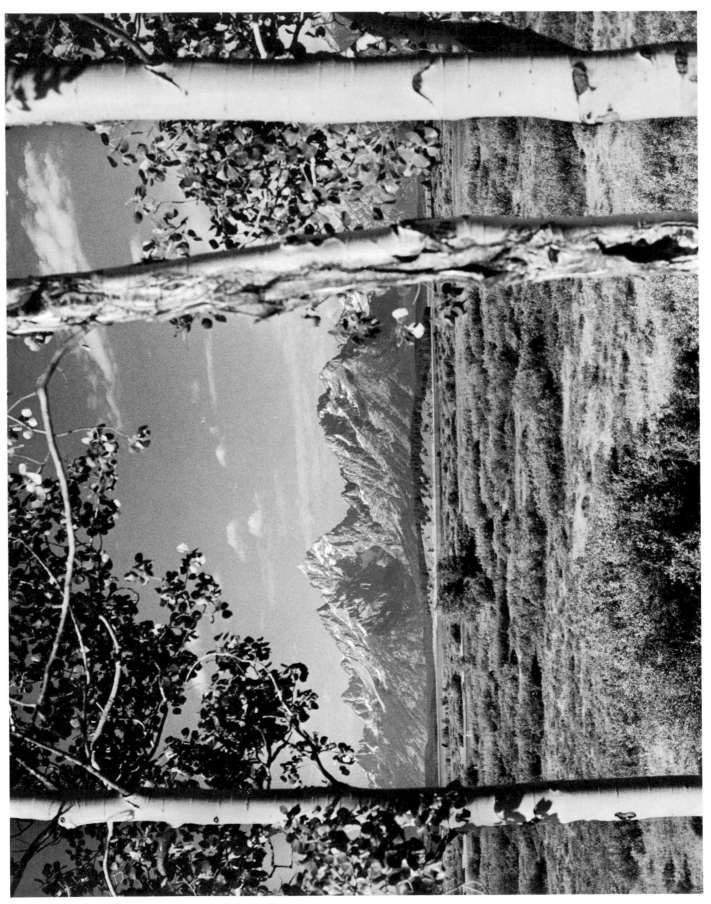

10 Wyoming: Grand Teton National Park.

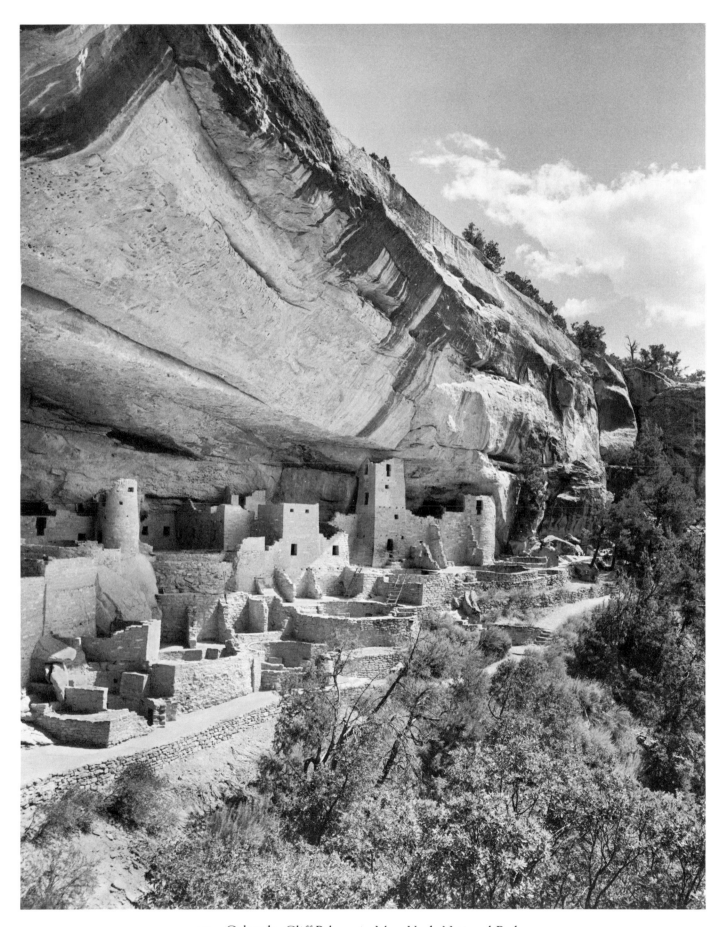

11 Colorado: Cliff Palace, in Mesa Verde National Park.

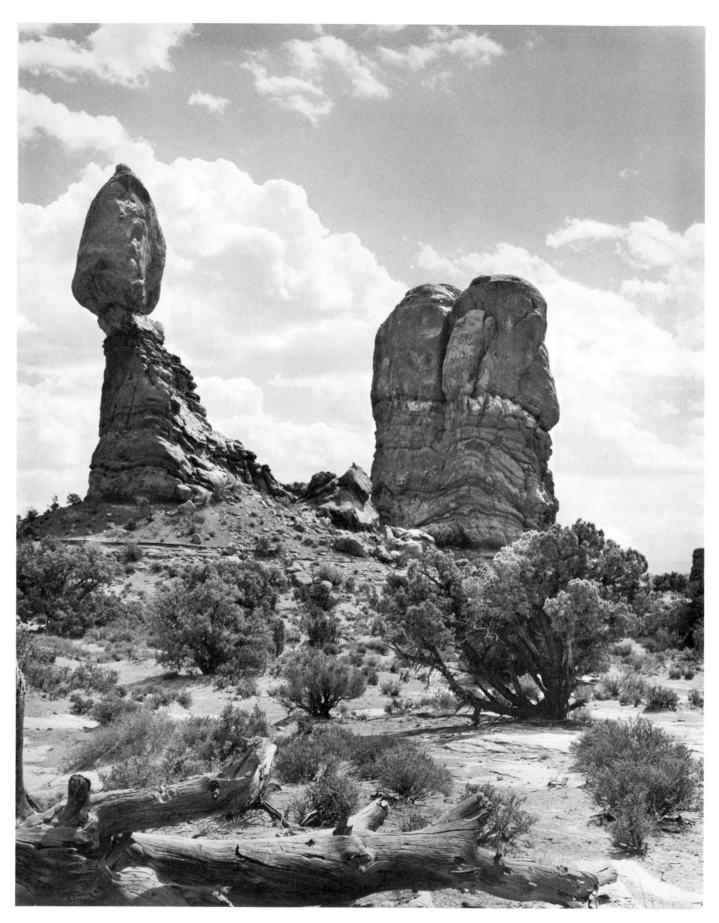

12 Utah: Arches National Park.

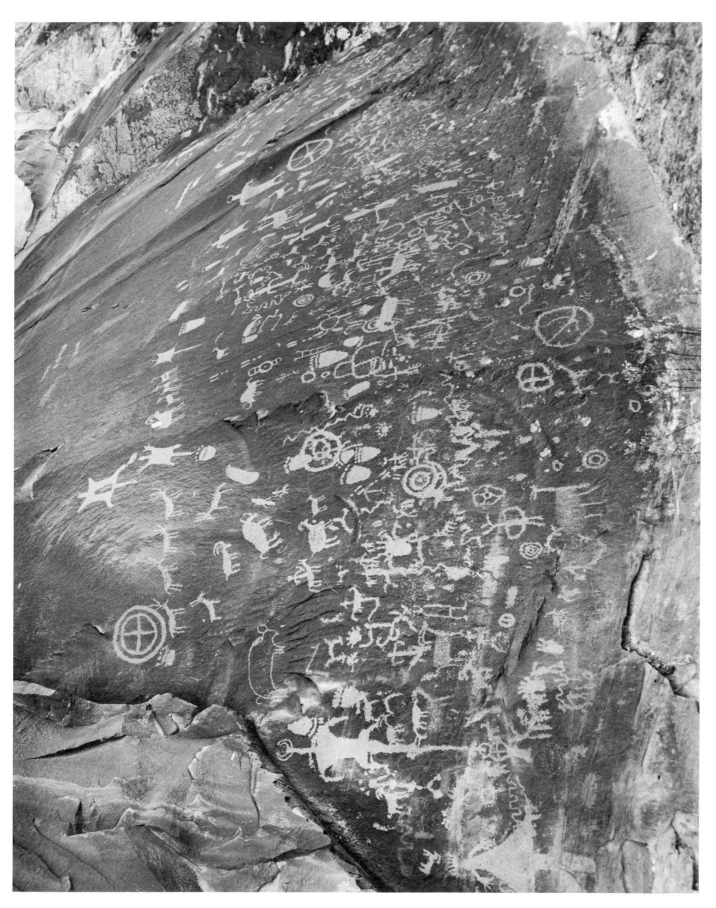

13 Utah: Indian petroglyphs.

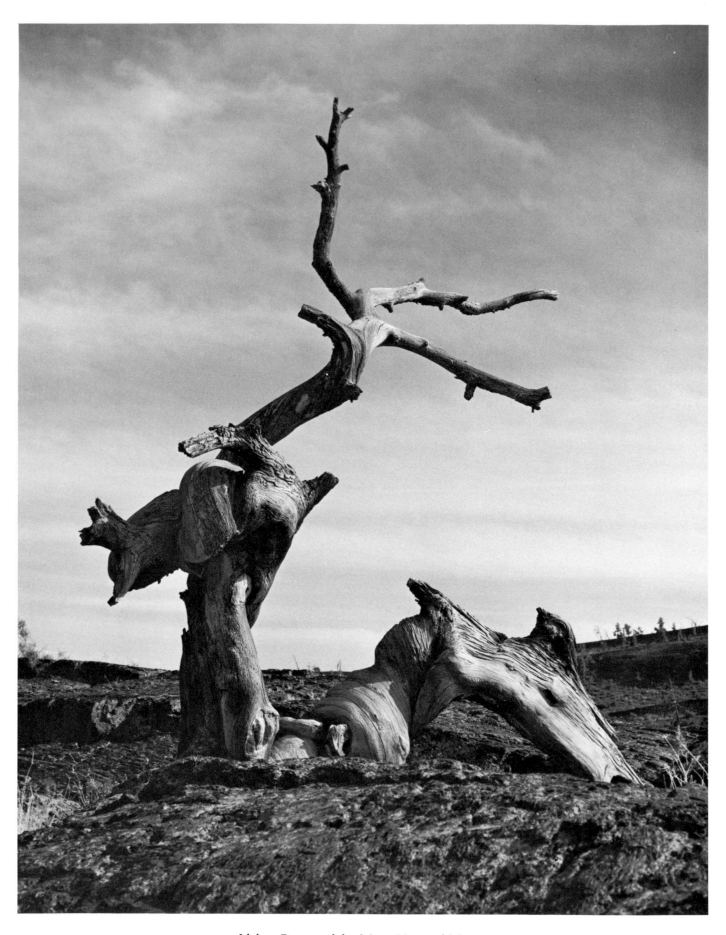

14 Idaho: Craters of the Moon National Monument.

15 Arizona: Grand Canyon National Park.

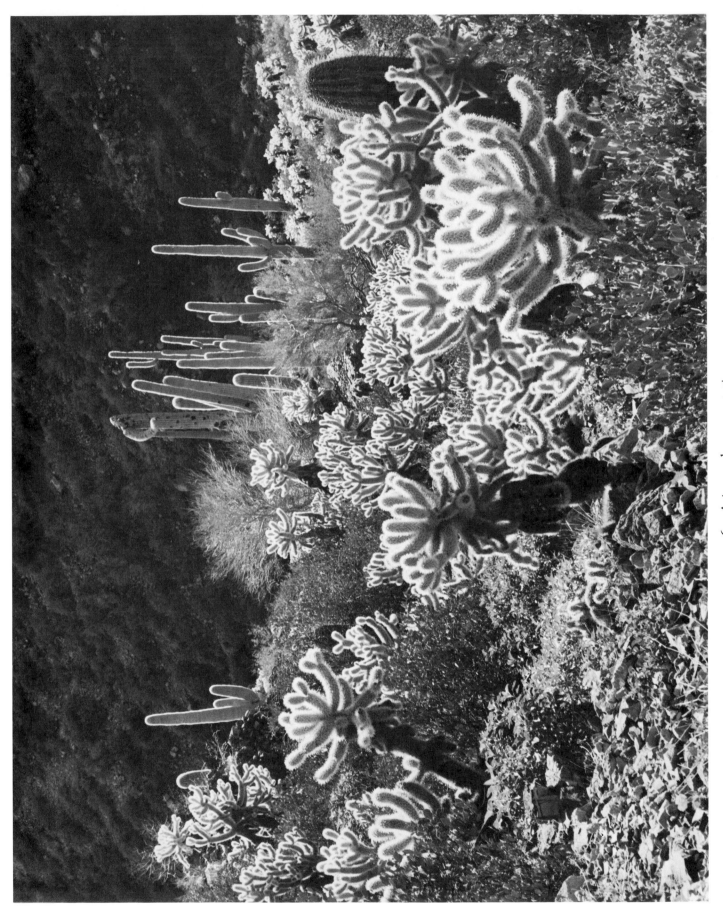

16 Arizona: desert vegetation.

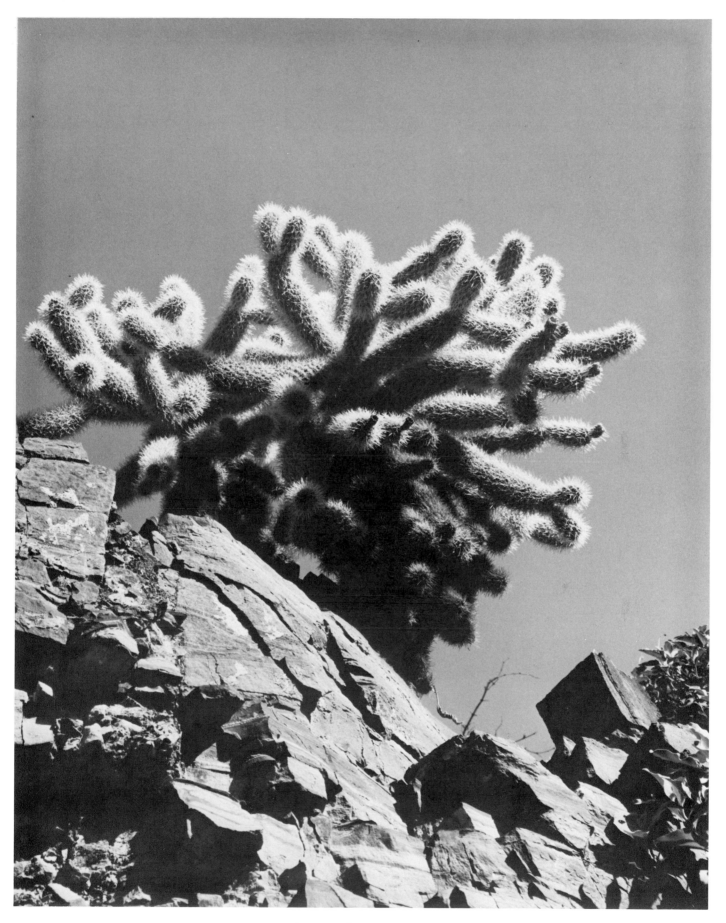

17 Arizona: desert vegetation.

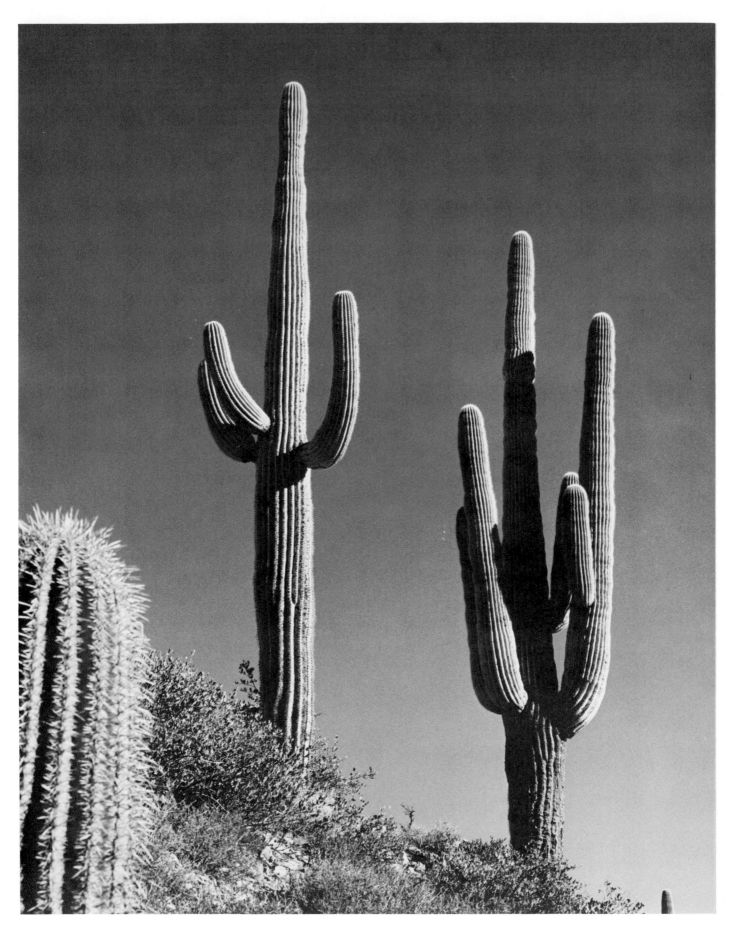

18 Arizona: Saguaro National Monument.

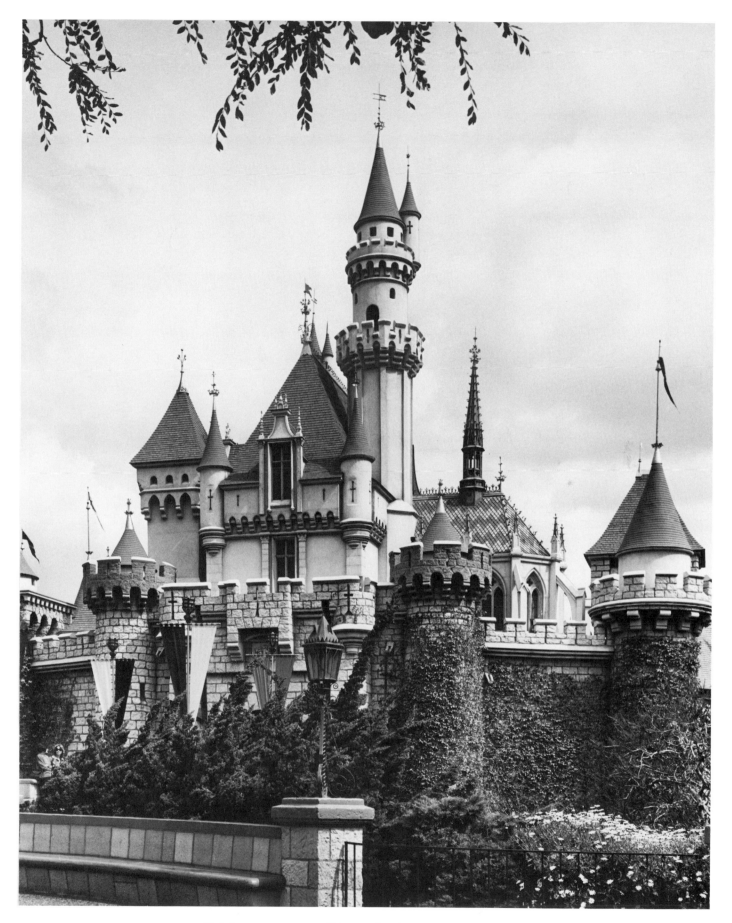

19 California: a corner of Fantasyland in Disneyland, Anaheim.

20 California: the Golden Gate Bridge, San Francisco.

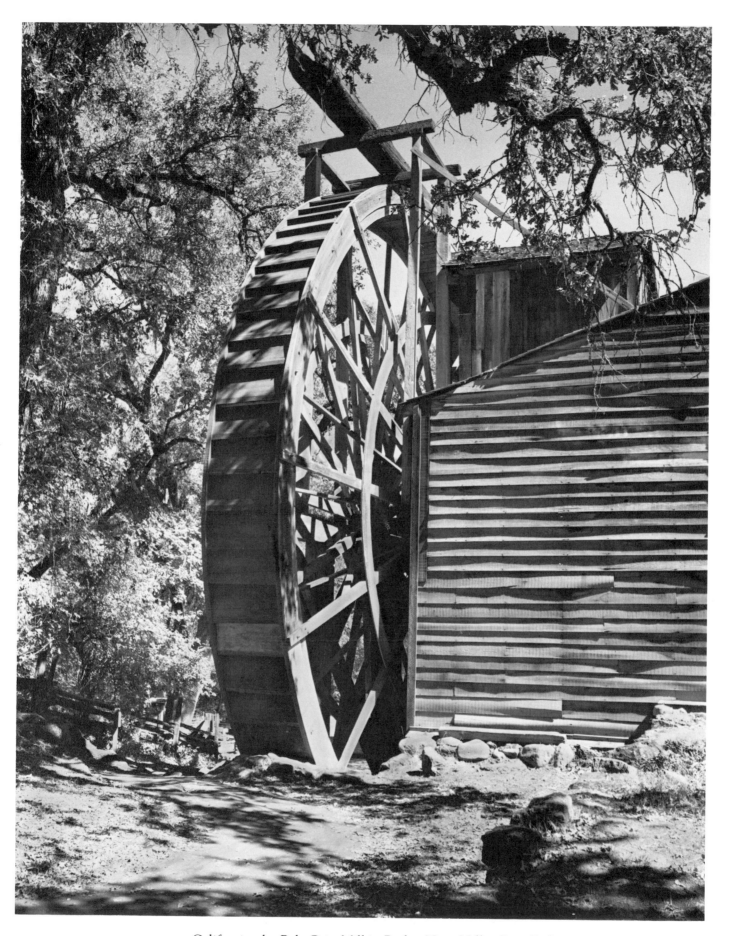

21 California: the Bale Grist Mill in Bothe–Napa Valley State Park.

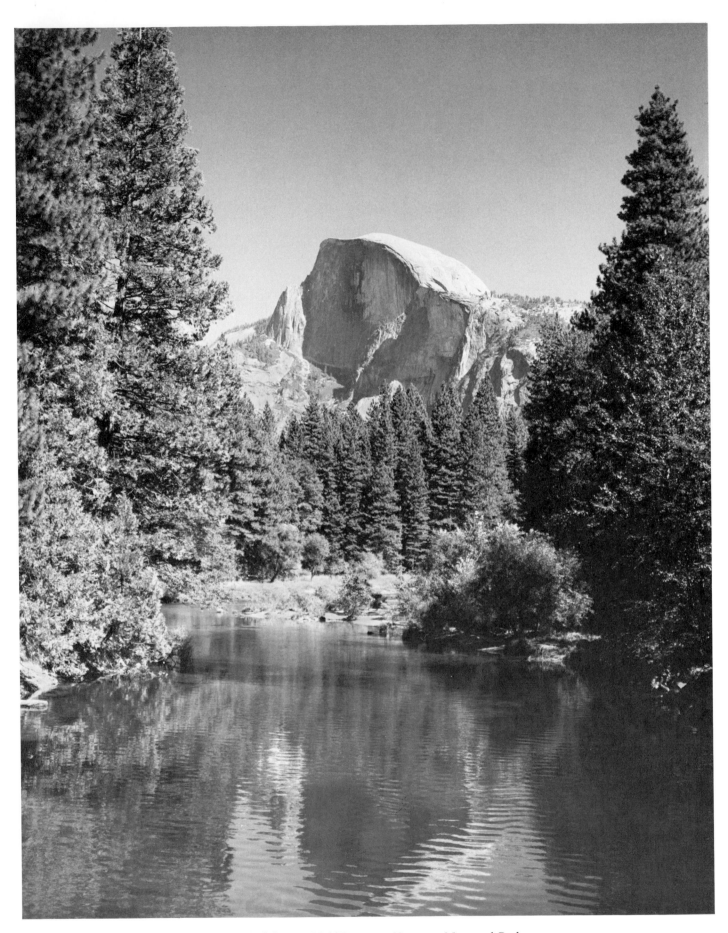

22 California: Half Dome in Yosemite National Park.

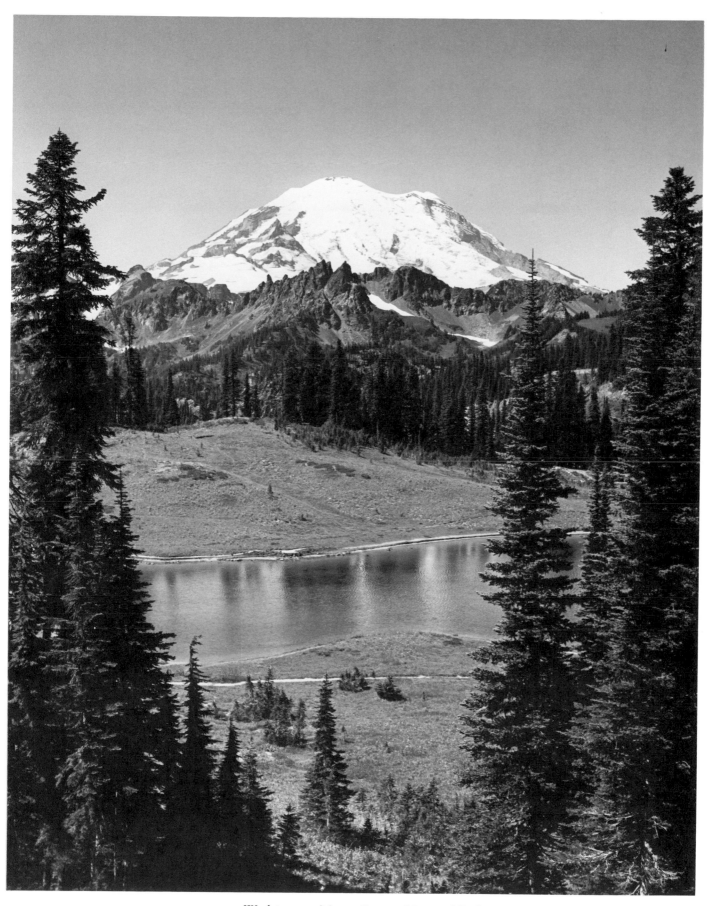

23 Washington: Mount Rainier National Park.

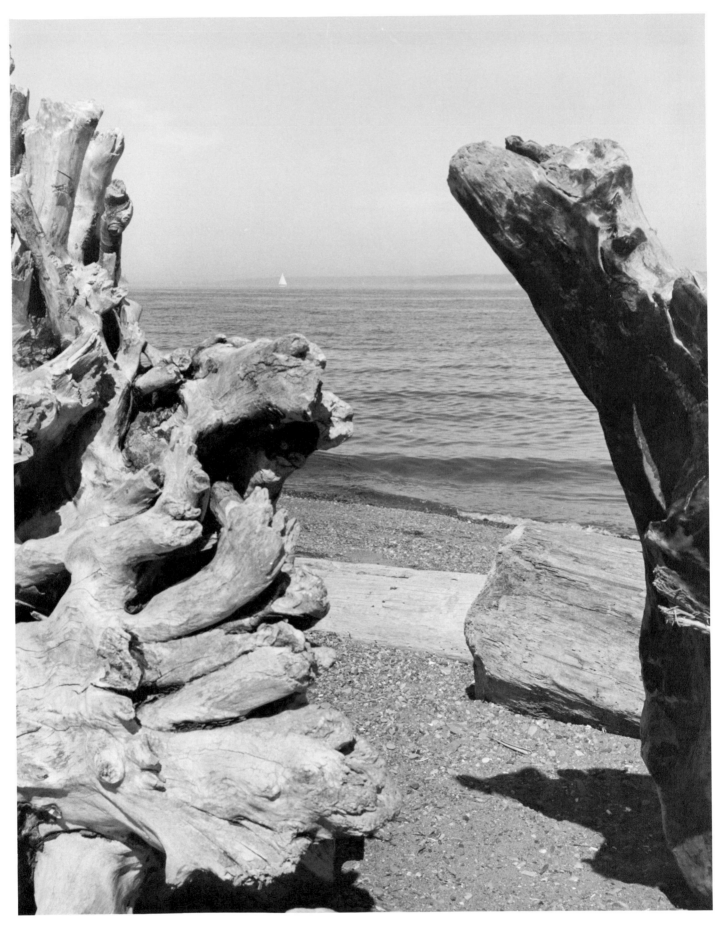

24 Washington: Bainbridge Island and Puget Sound.

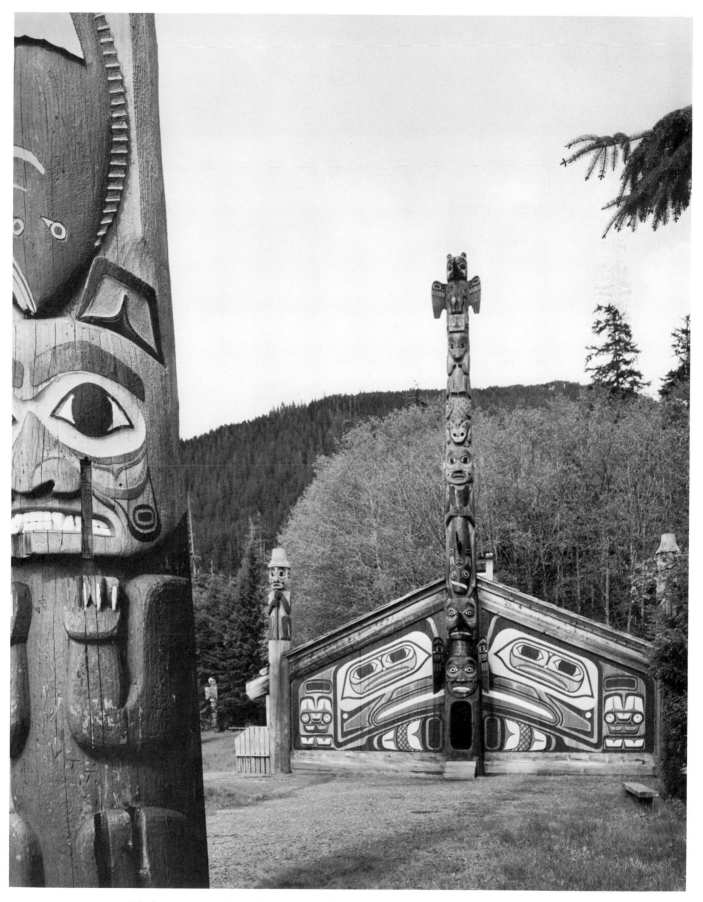

25 Alaska: totem poles and ceremonial house, Totem Bight State Park, near Ketchikan.

26 Alaska: coastline in the southeast.

27 Alaska: near Skagway.

28 Mexico: the Pyramid of the Sun, Teotihuacán.

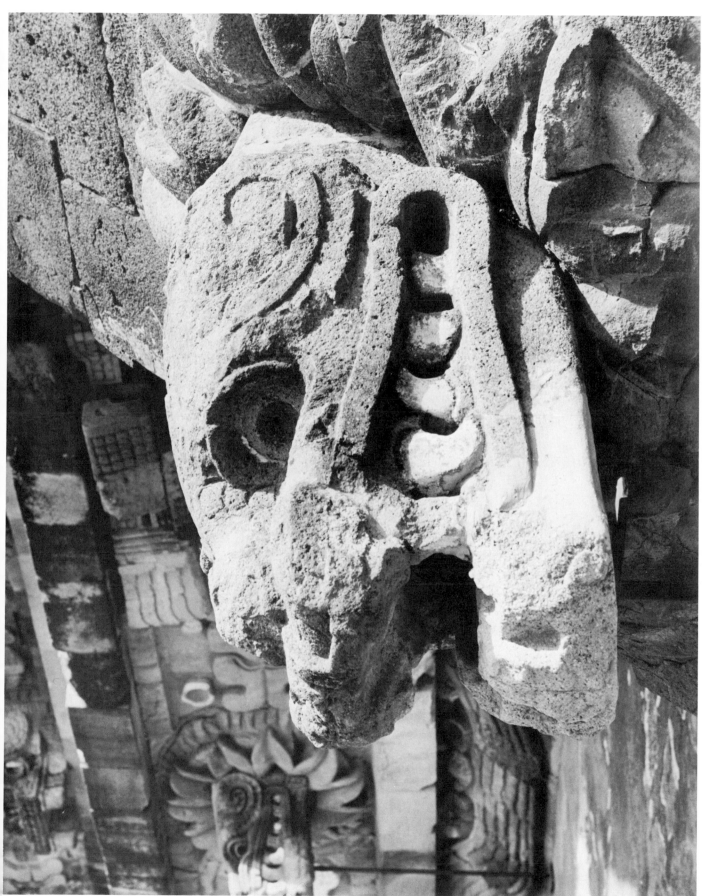

29 Mexico: detail of the Temple of Quetzalcóatl, Teotihuacán.

30 Mexico: Chacmool statue and "El Castillo," Chichén Itzá, Yucatán.

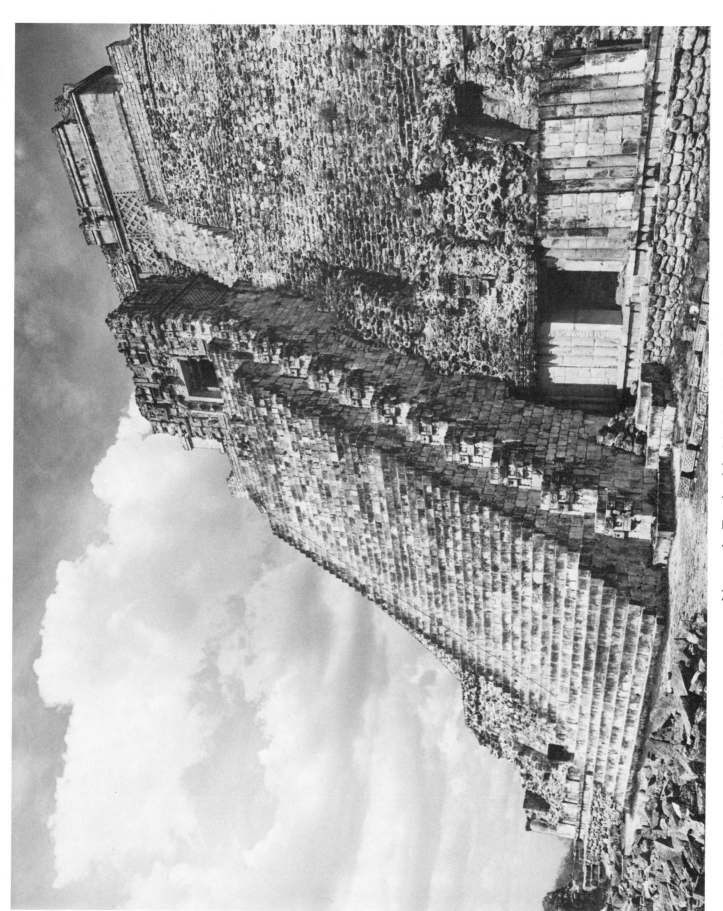

31 Mexico: the Temple of the Magician, Uxmal, Yucatán.

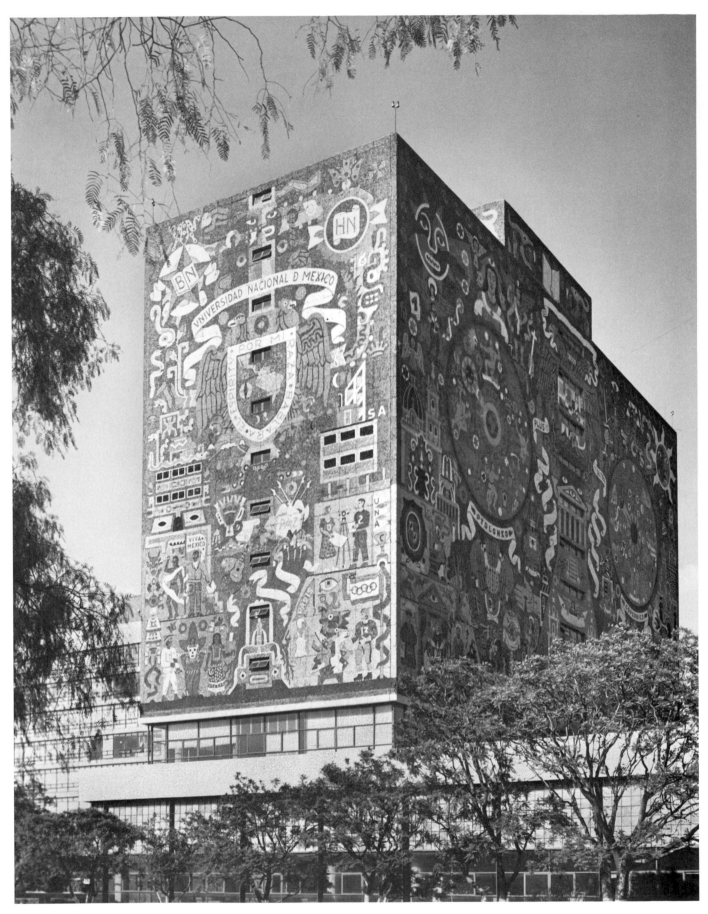

32 Mexico: the university library building, Mexico City.

33 Panama: Miraflores Locks, Panama Canal.

34 Peru: the Inca ruins of Machu Picchu, near Cuzco.

35 Brazil: Rio de Janeiro, with Sugarloaf Mountain.

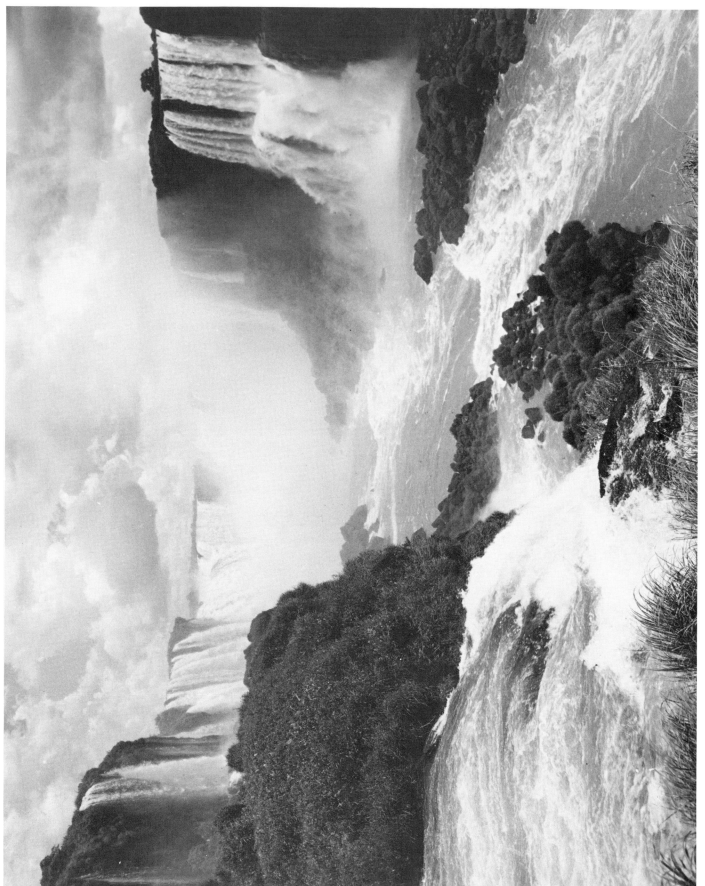

36 Iguassú Falls, between Brazil and Argentina.

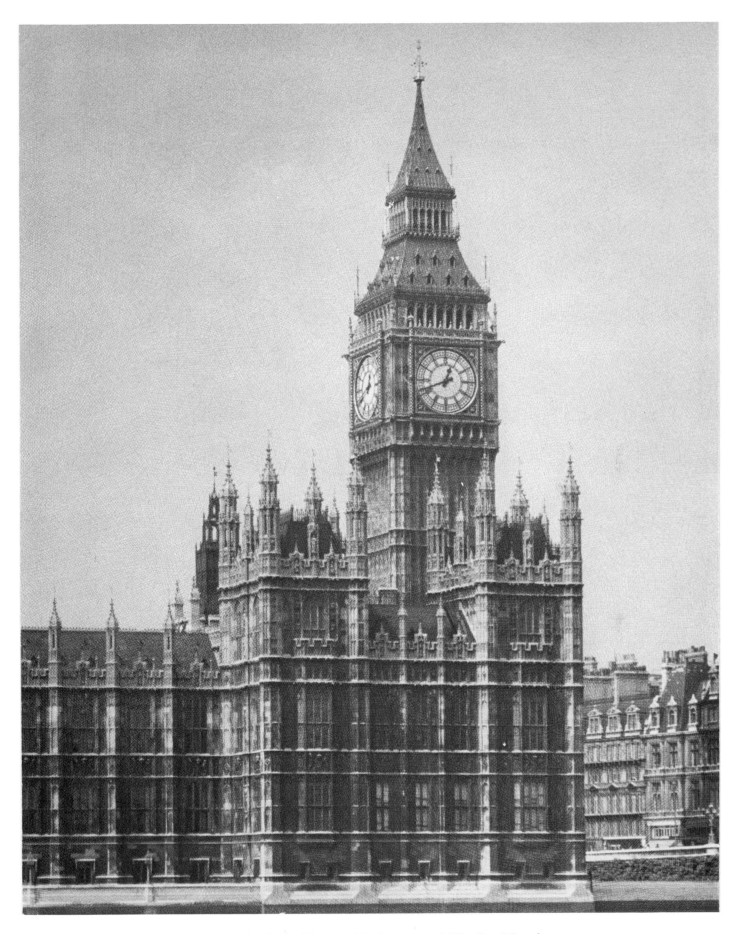

37 England: the Houses of Parliament and "Big Ben," London.

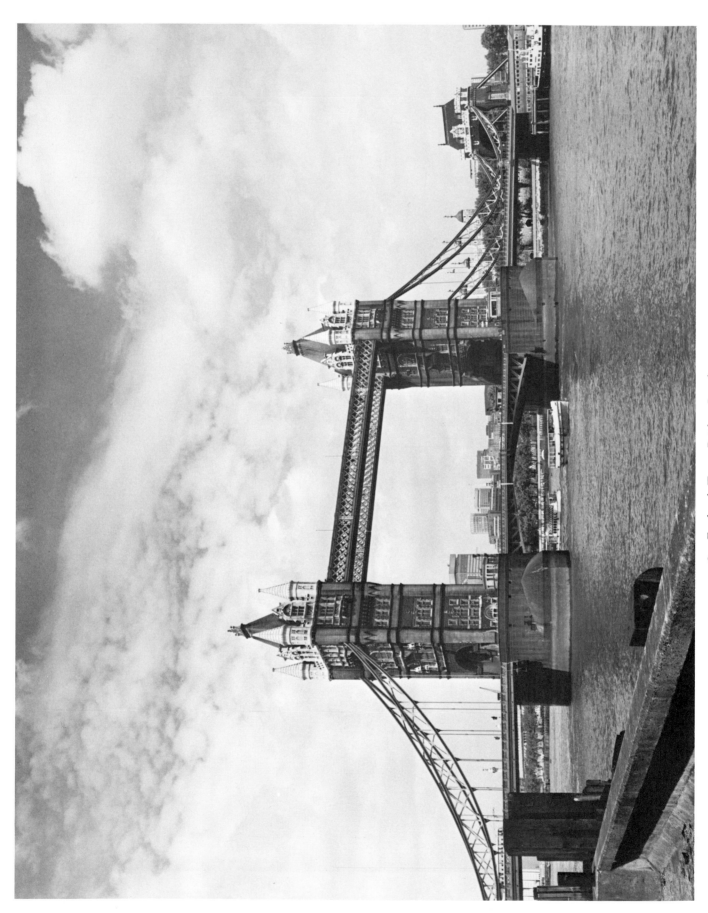

38 England: Tower Bridge, London.

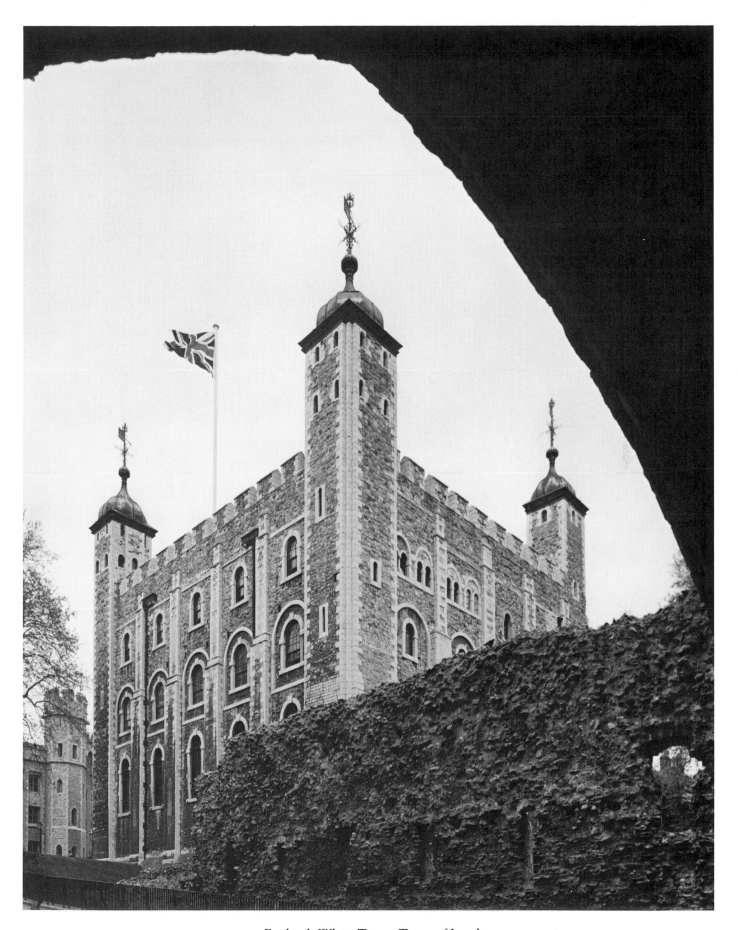

39 England: White Tower, Tower of London.

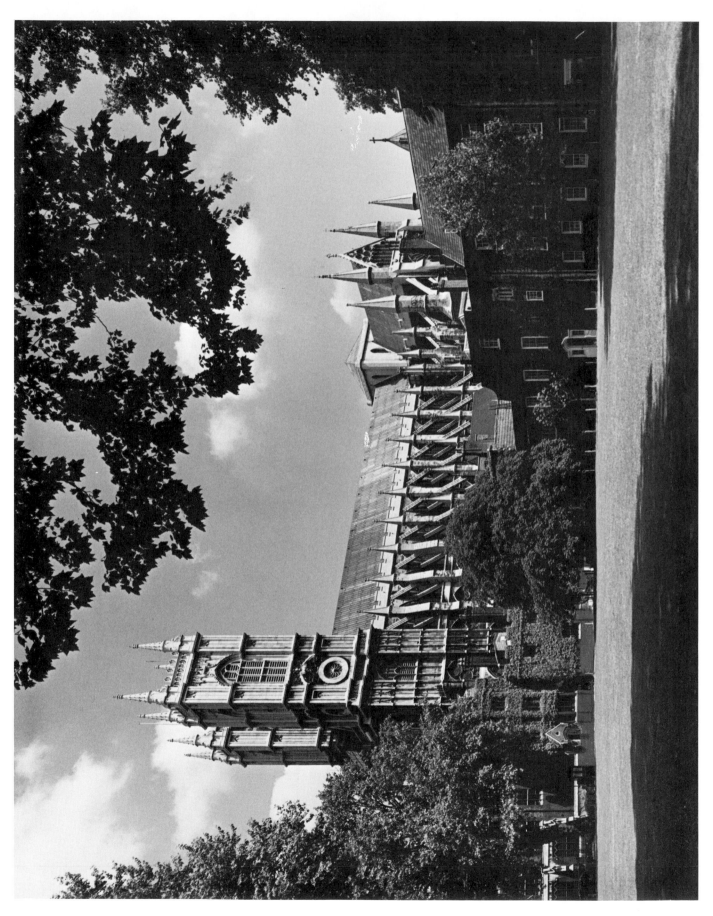

40 England: Westminster Abbey, London.

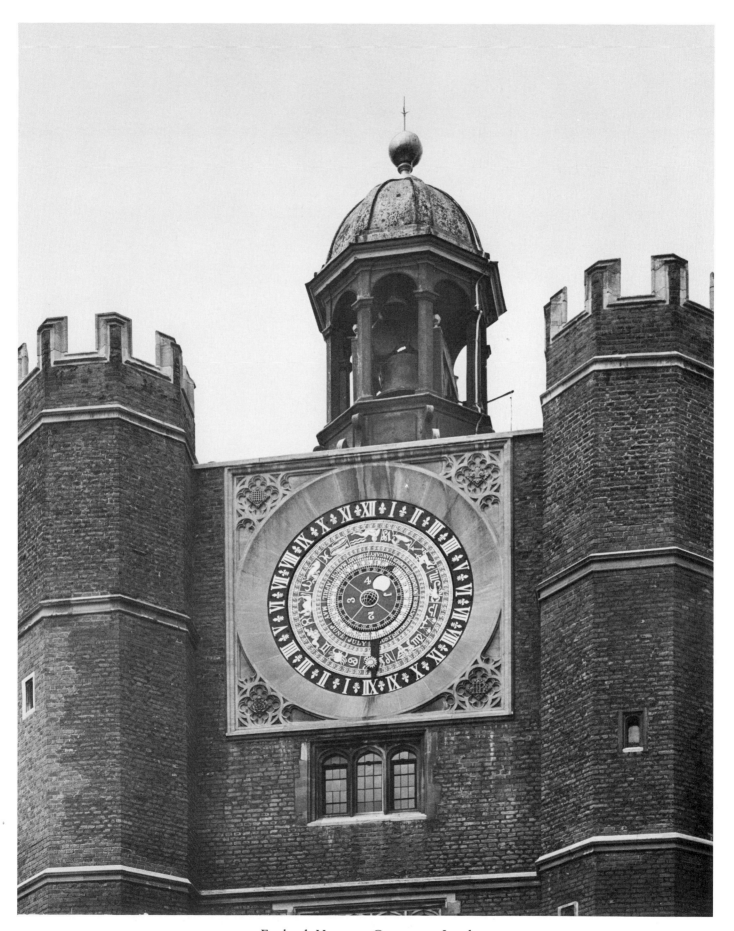

41 England: Hampton Court, near London.

42 England: Stonehenge, on Salisbury Plain.

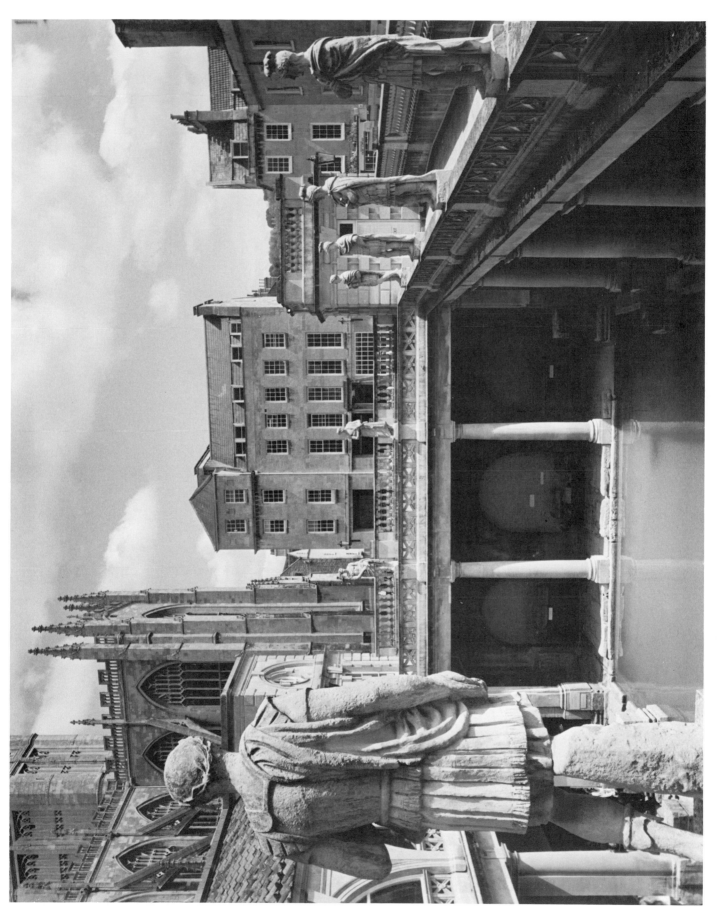

43 England: the Roman baths, Bath, with the abbey church in the background.

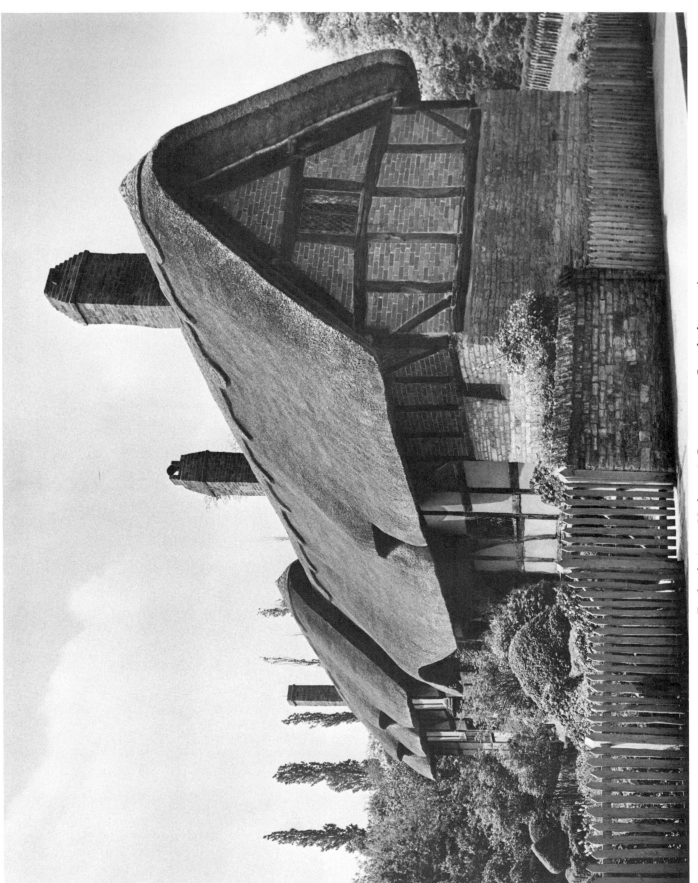

44　England: Anne Hathaway's Cottage, near Stratford-upon-Avon.

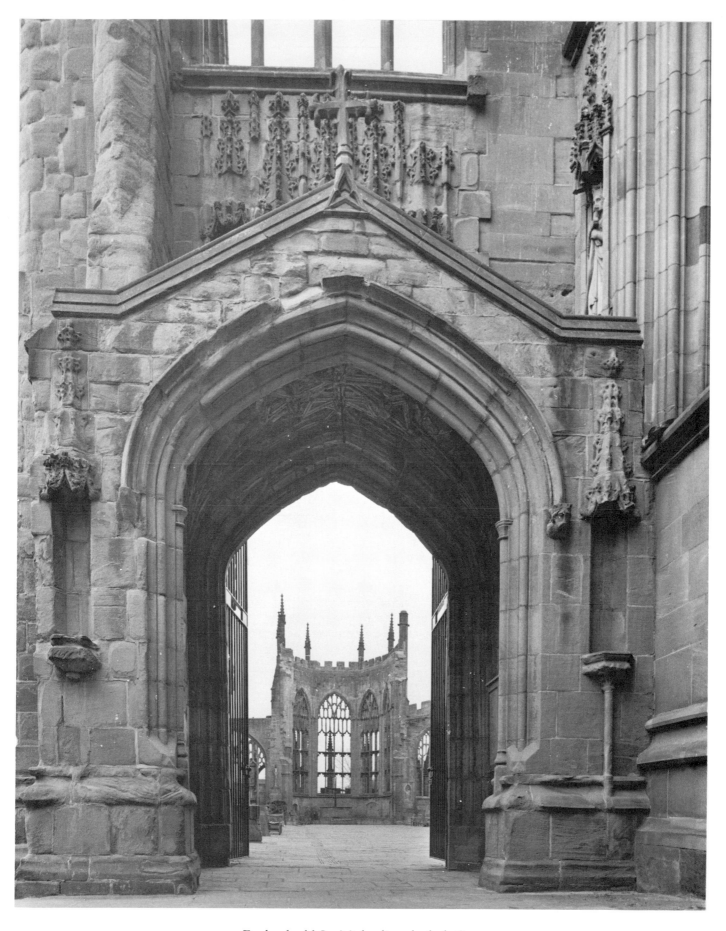

45 England: old St. Michael's cathedral, Coventry.

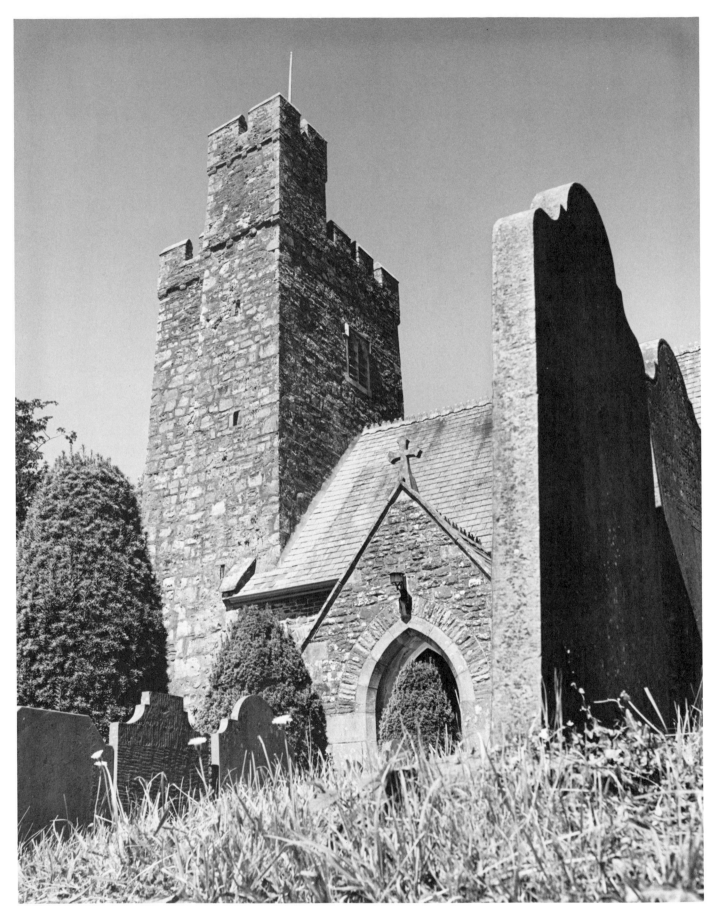

46 England: parish church incorporating a Norman tower.

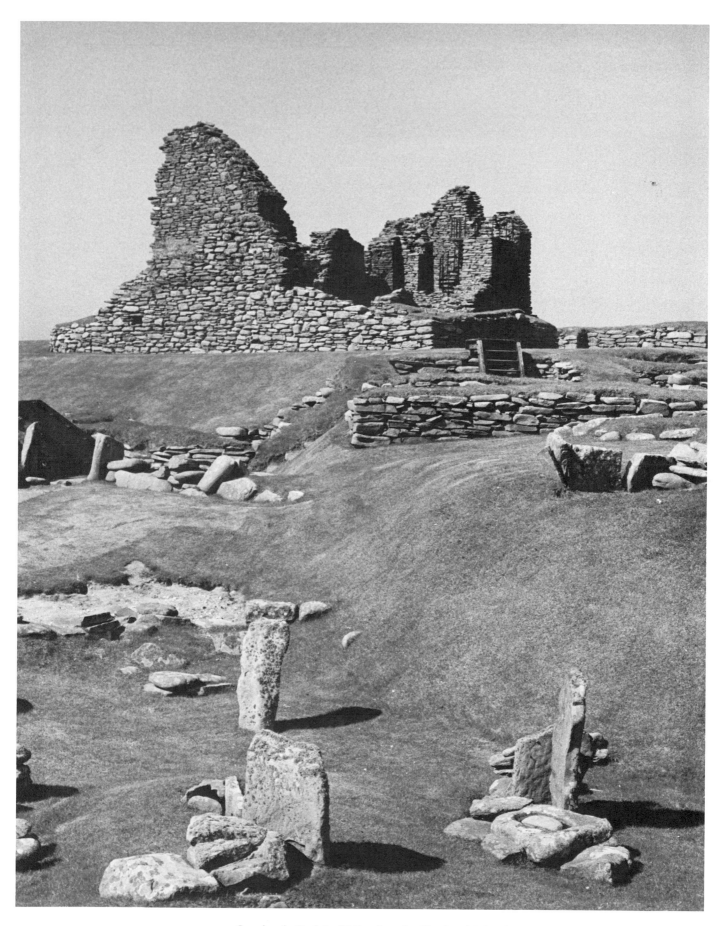

47 Scotland: "Jarlshof," Sumburgh, Shetland Islands.

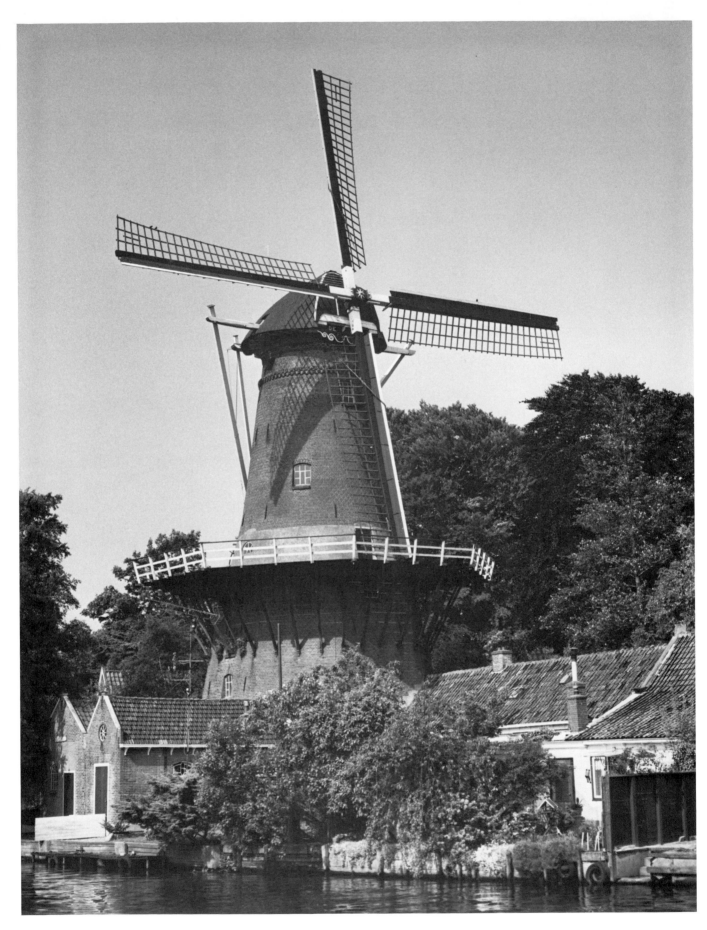

48 Netherlands: typical windmill.

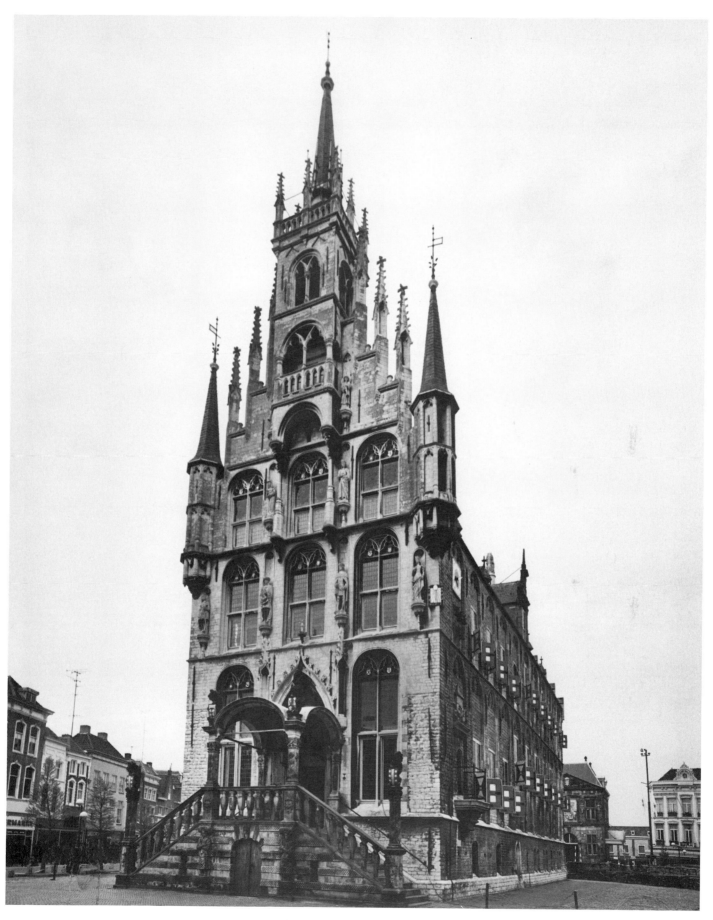

49 Netherlands: the town hall, Gouda.

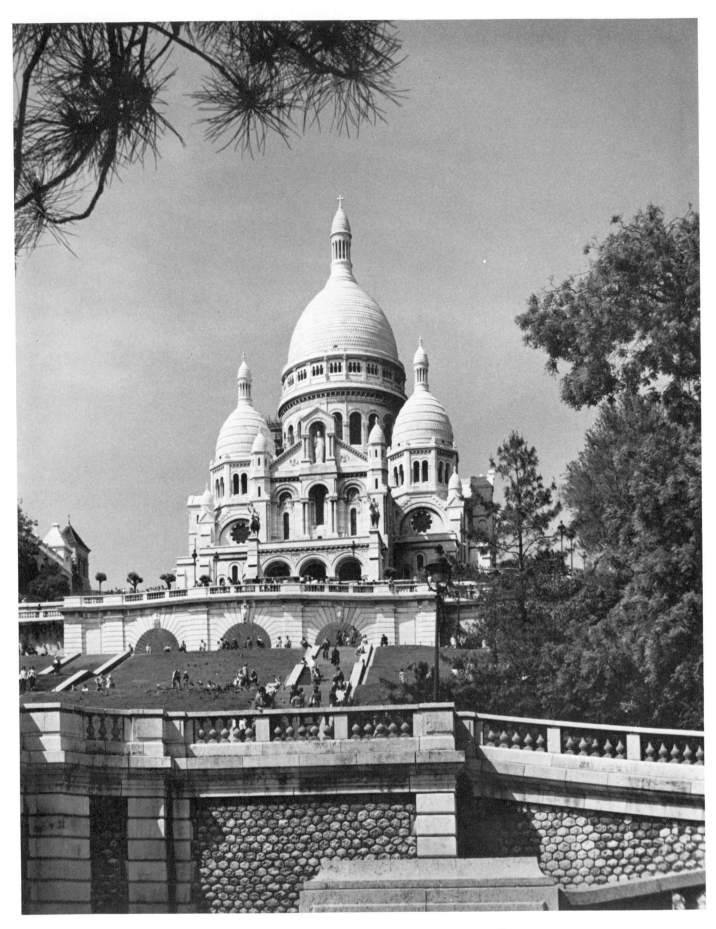

50 France: the Sacré-Coeur Basilica, Montmartre, Paris.

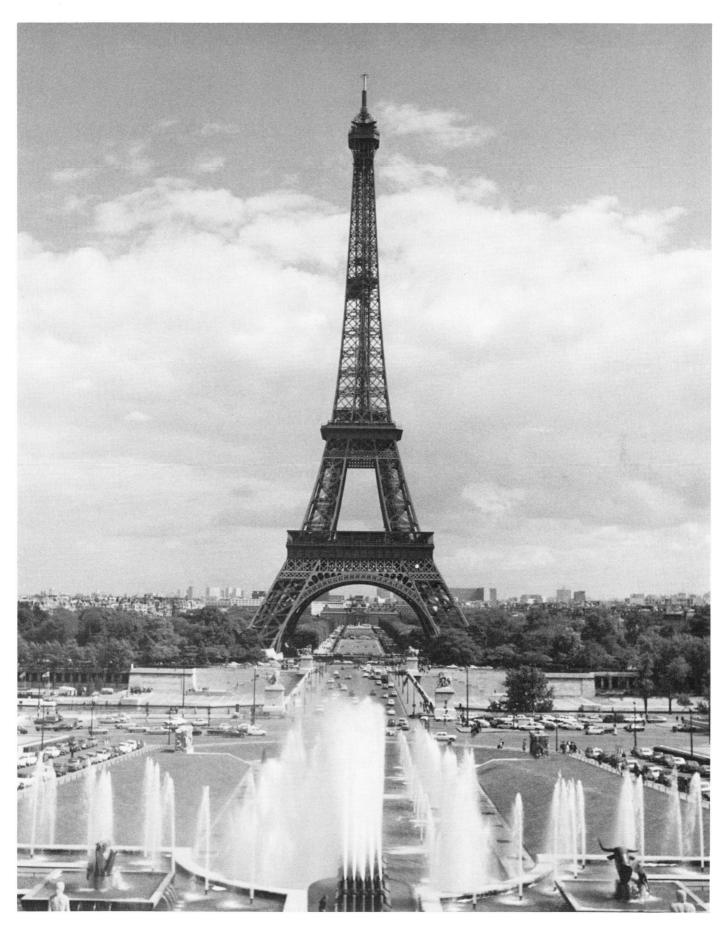

51 France: the Eiffel Tower, Paris.

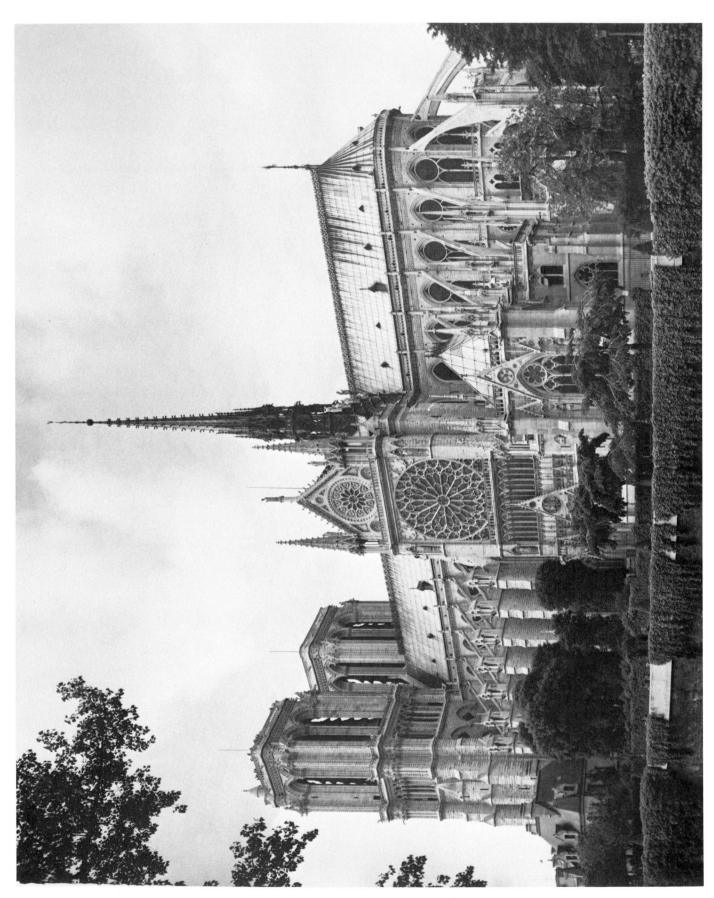

52 France: Notre-Dame Cathedral, Paris.

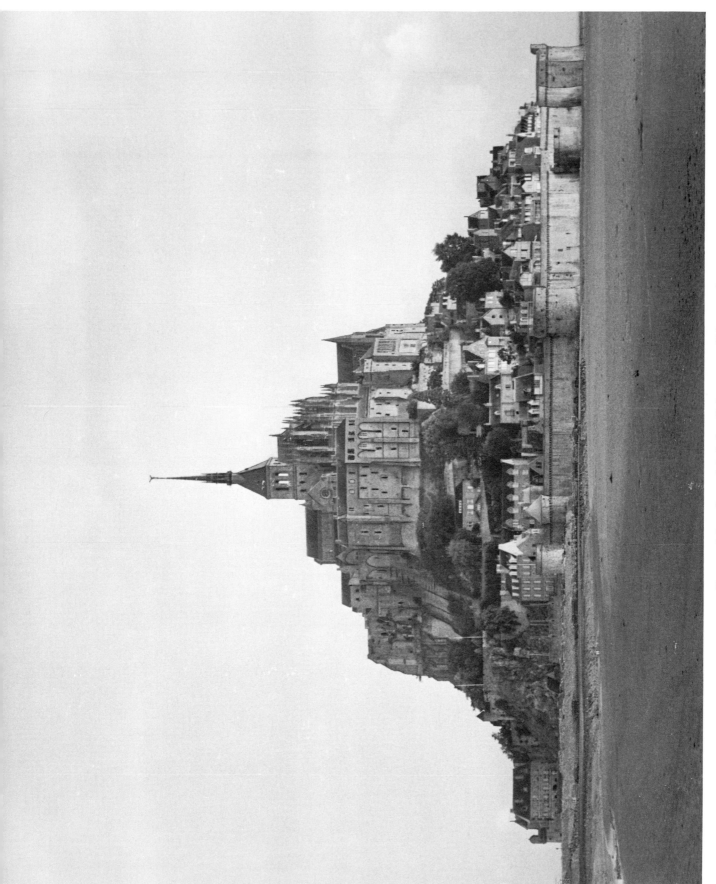

53 France: Mont-Saint-Michel, off the coast of Normandy.

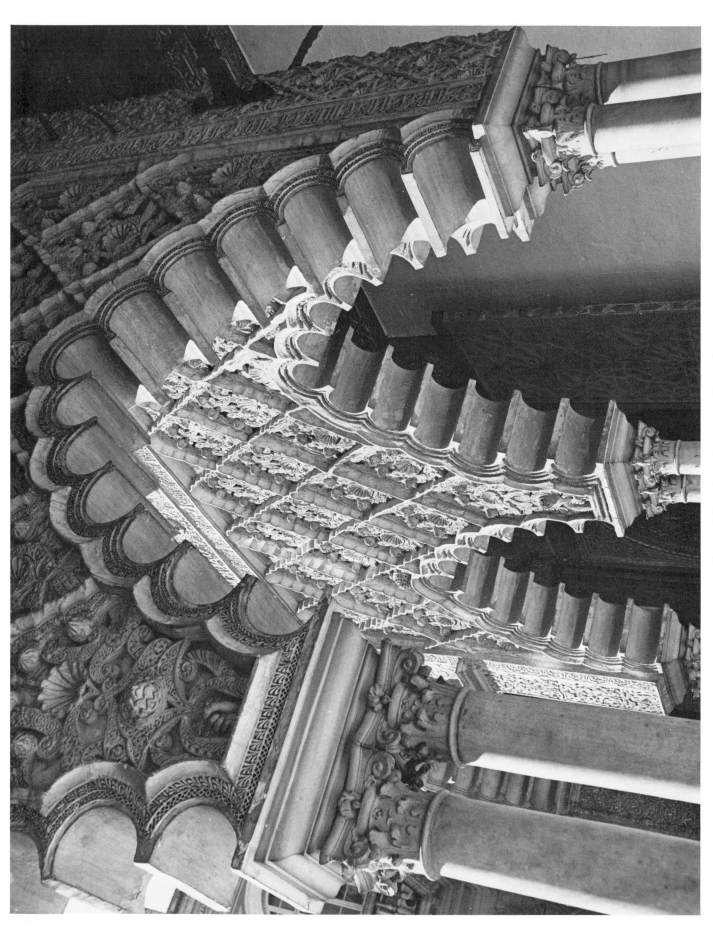

54 Spain: Moorish architecture, Granada.

55 Spain: Court of the Lions, Alhambra Palace, Granada.

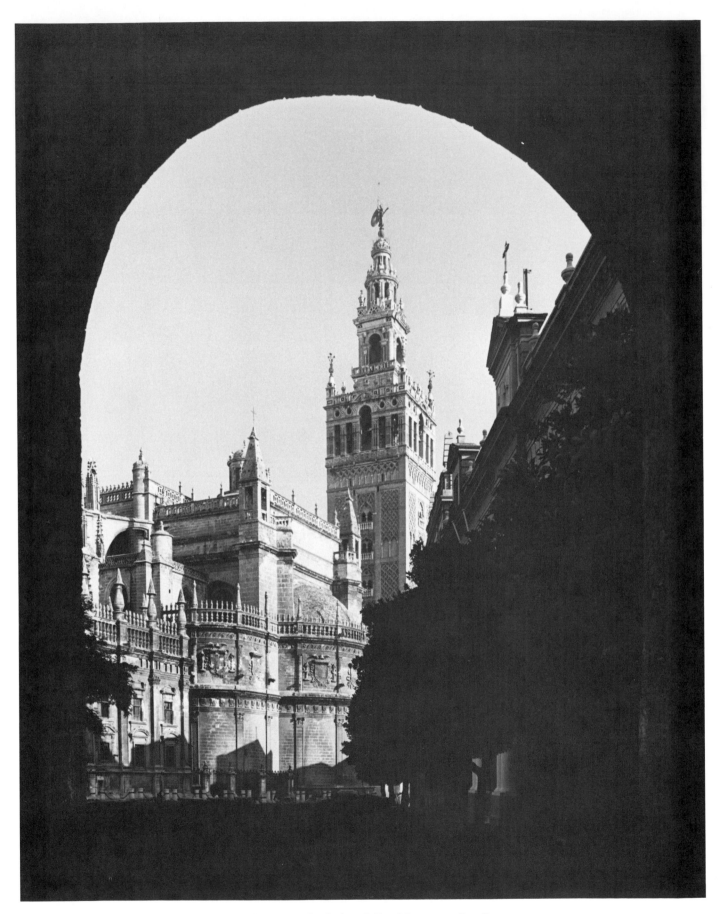

56 Spain: cathedral and Giralda tower, Seville.

57 Portugal: abbey of Santa Maria da Vitória, Batalha.

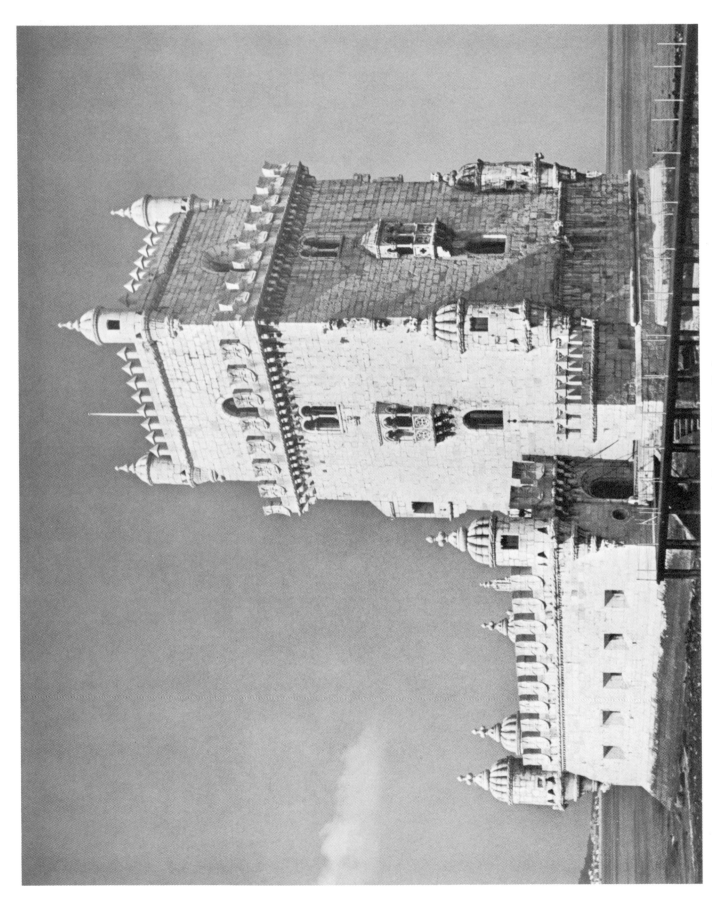

58 Portugal: Tower of Belém, Lisbon.

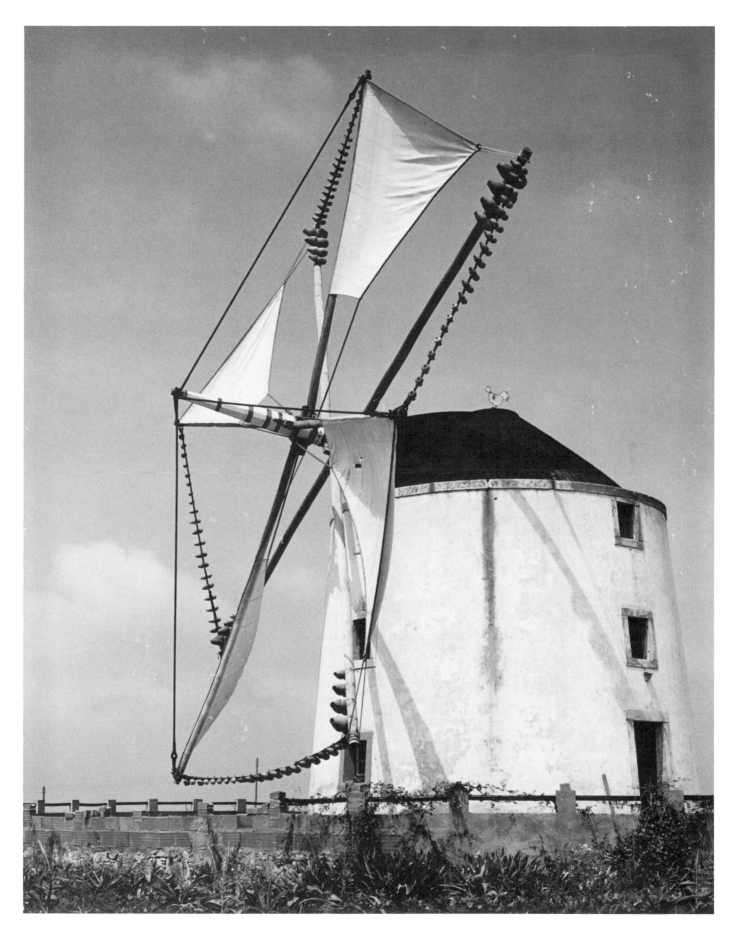

59 Portugal: typical windmill.

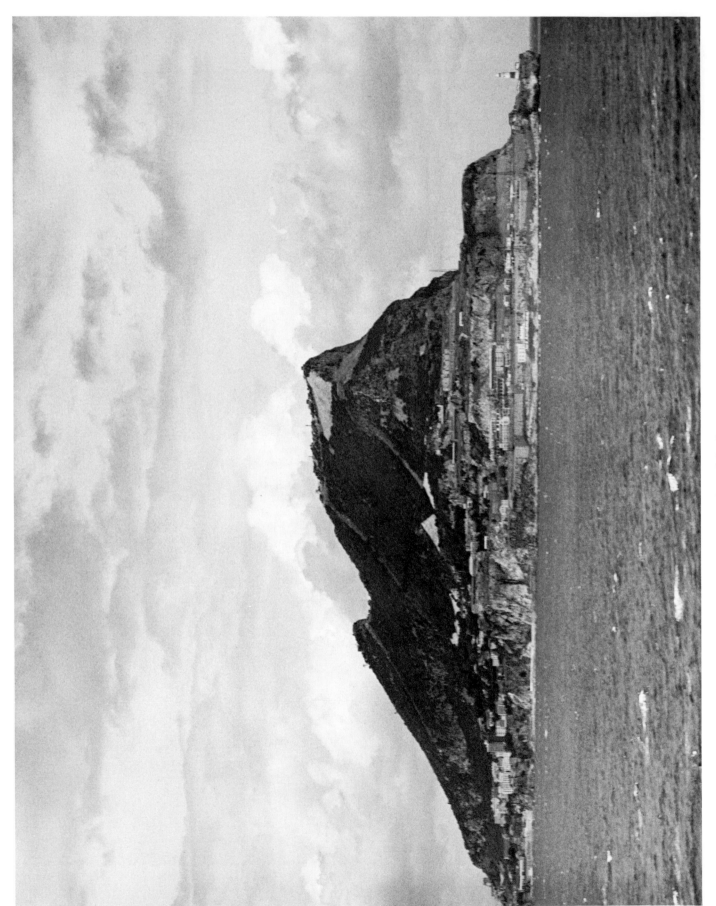

60 Gibraltar.

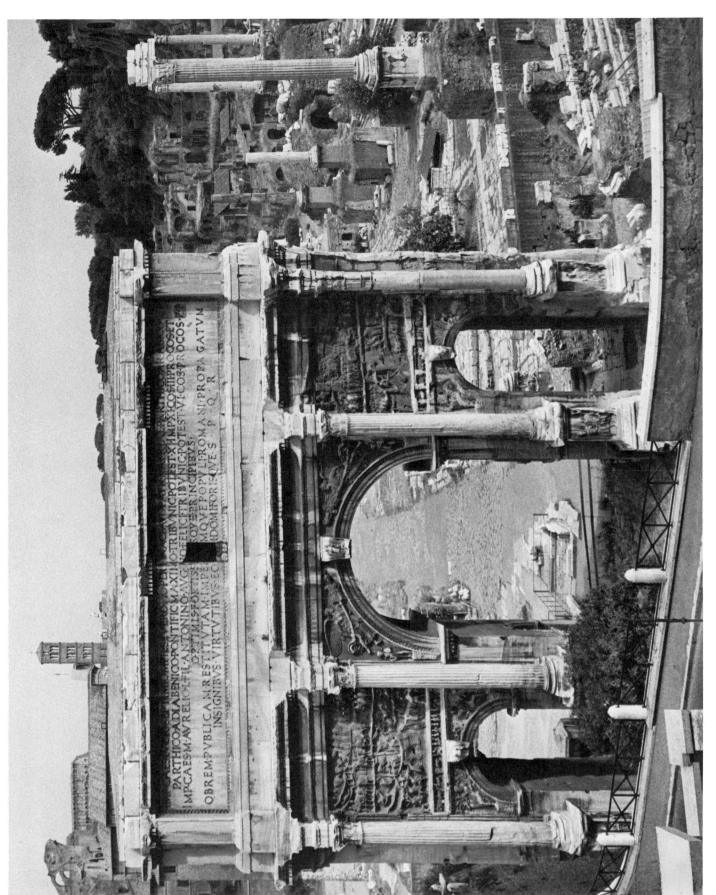

61 Italy: the Arch of Septimius Severus and the Roman Forum, Rome.

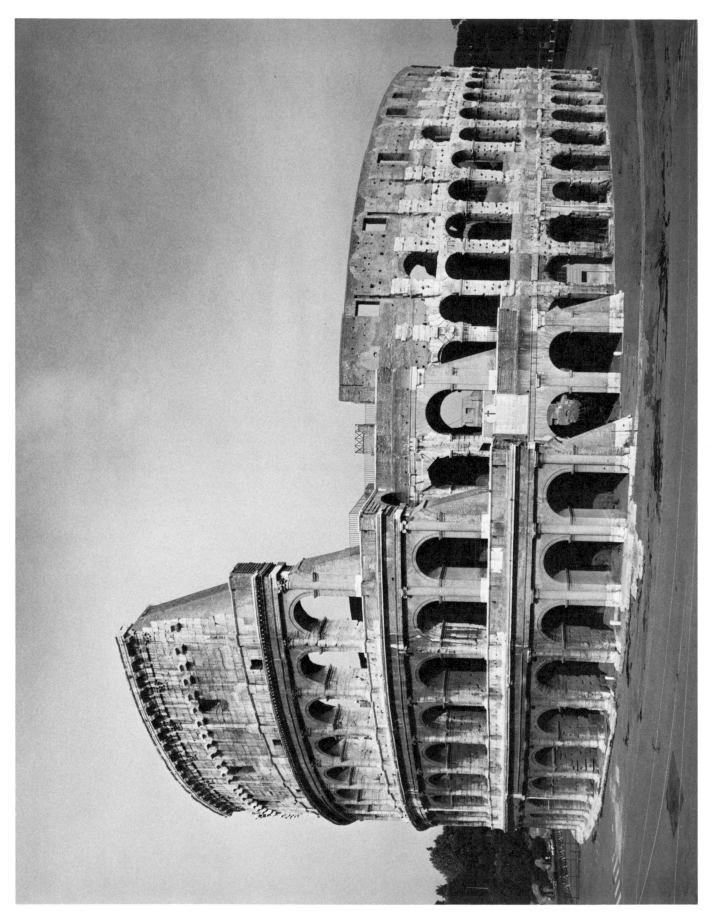

62 Italy: Colosseum, Rome.

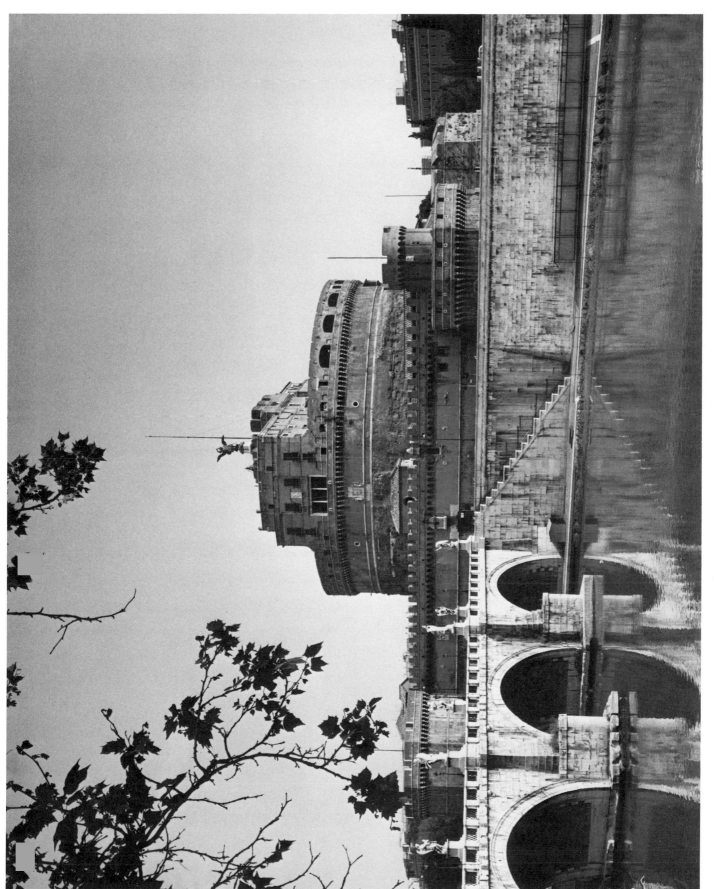

63 Italy: Castel Sant'Angelo and Ponte Sant'Angelo, Rome.

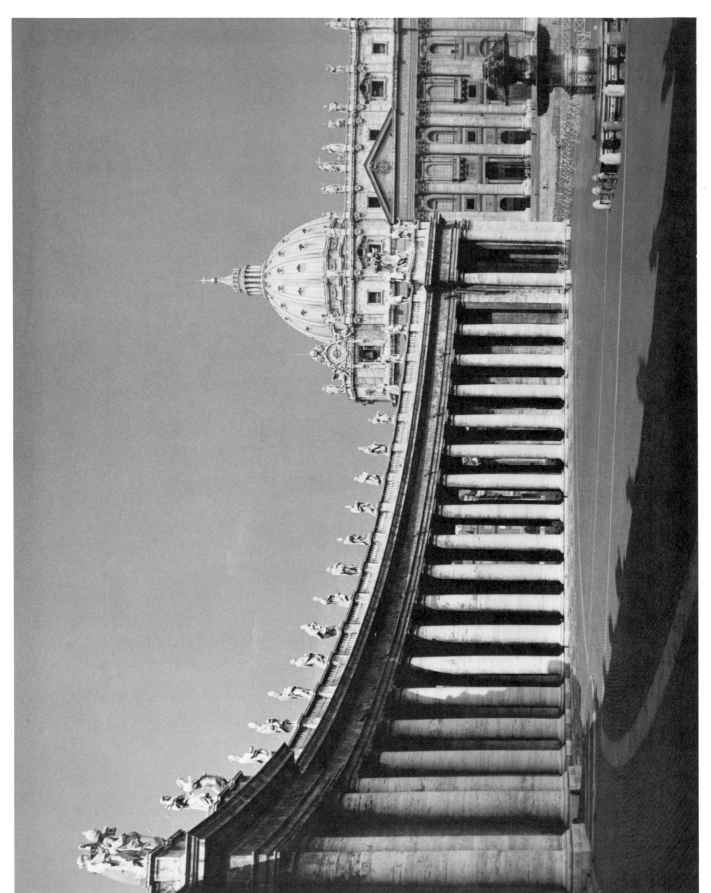

64 Italy: St. Peter's Basilica, with part of the colonnades, Rome.

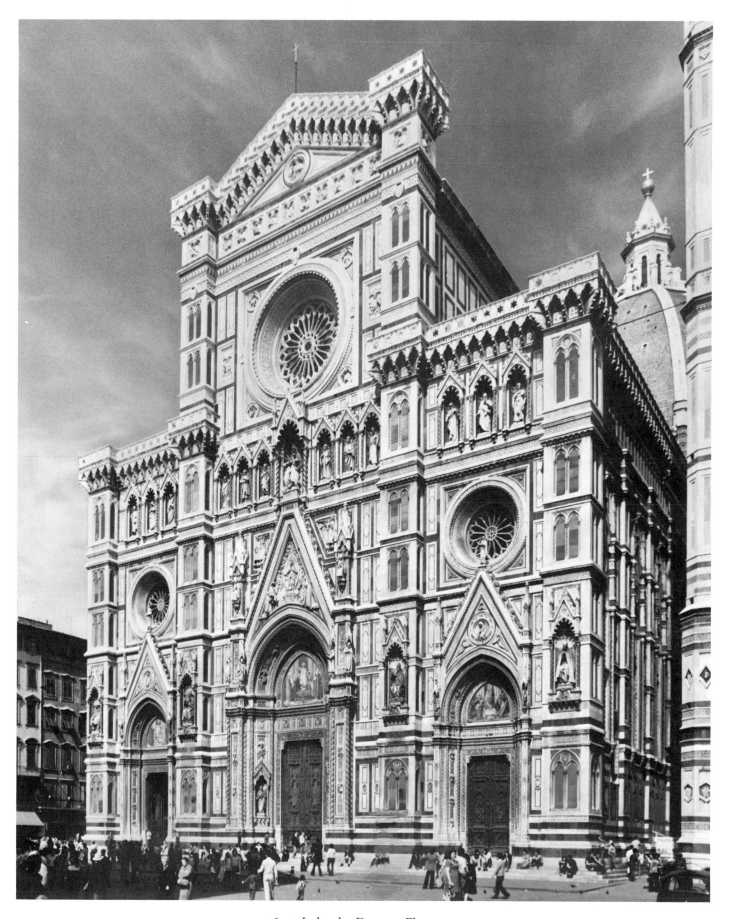

65 Italy: the Duomo, Florence.

66 Italy: the House of the Faun, Pompeii.

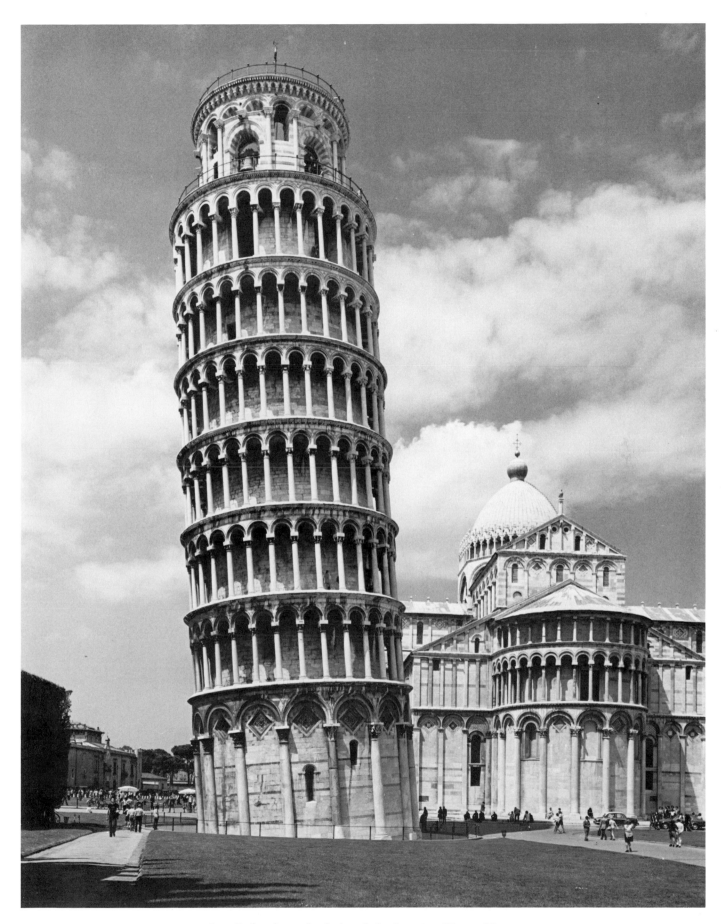

67 Italy: the cathedral and the Leaning Tower, Pisa.

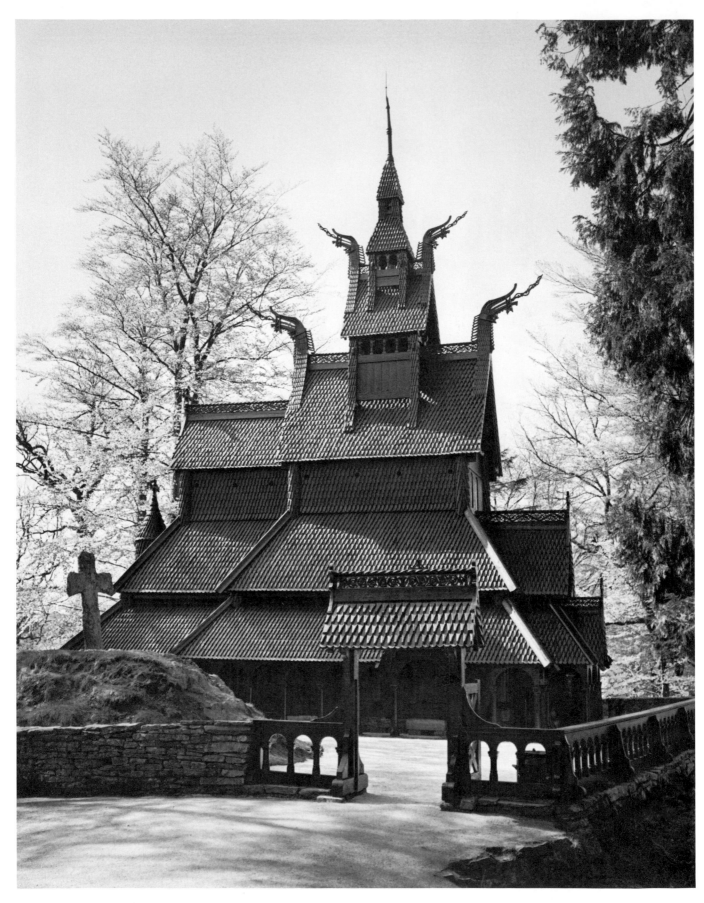

68 Norway: the Fantoft stave church at Bergen.

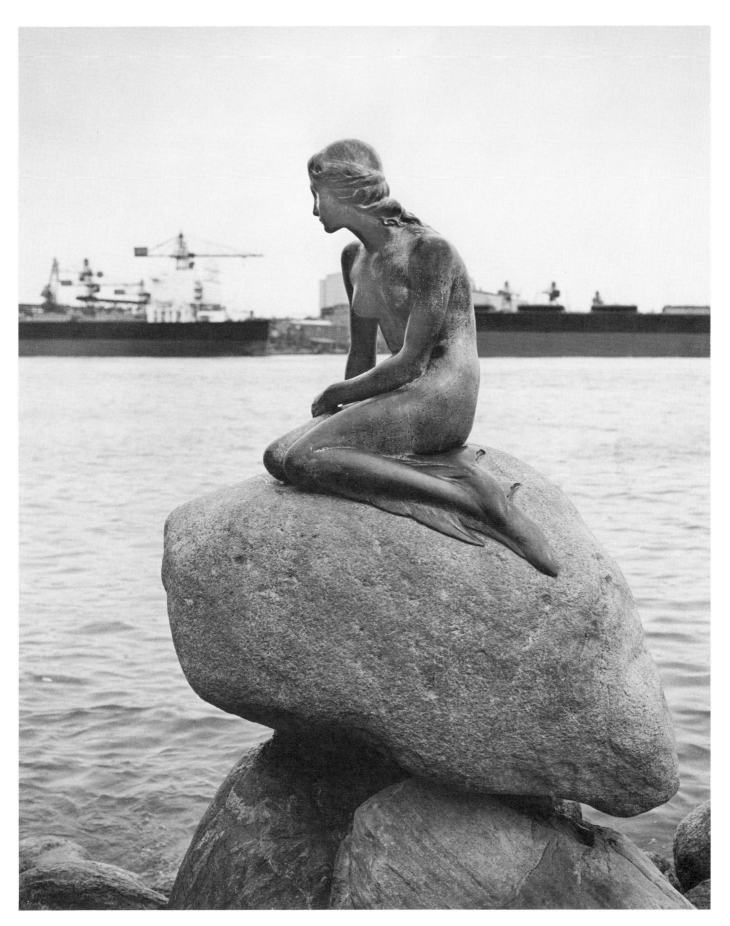

69 Denmark: the Little Mermaid statue, Copenhagen.

70 Finland: Sibelius Monument, Helsinki.

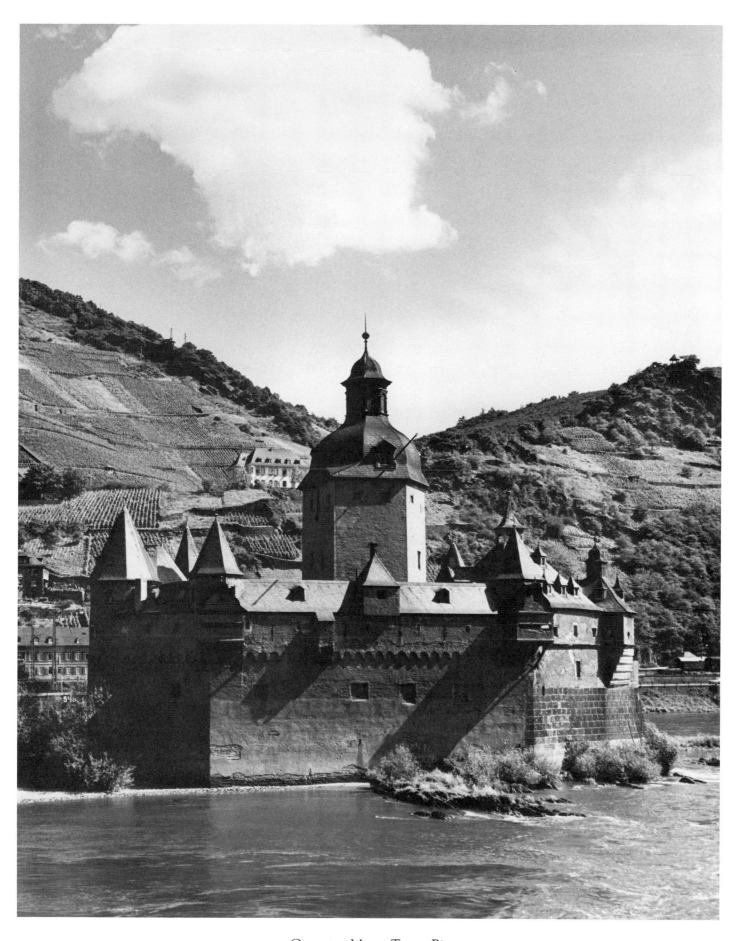

71 Germany: Mouse Tower, Bingen.

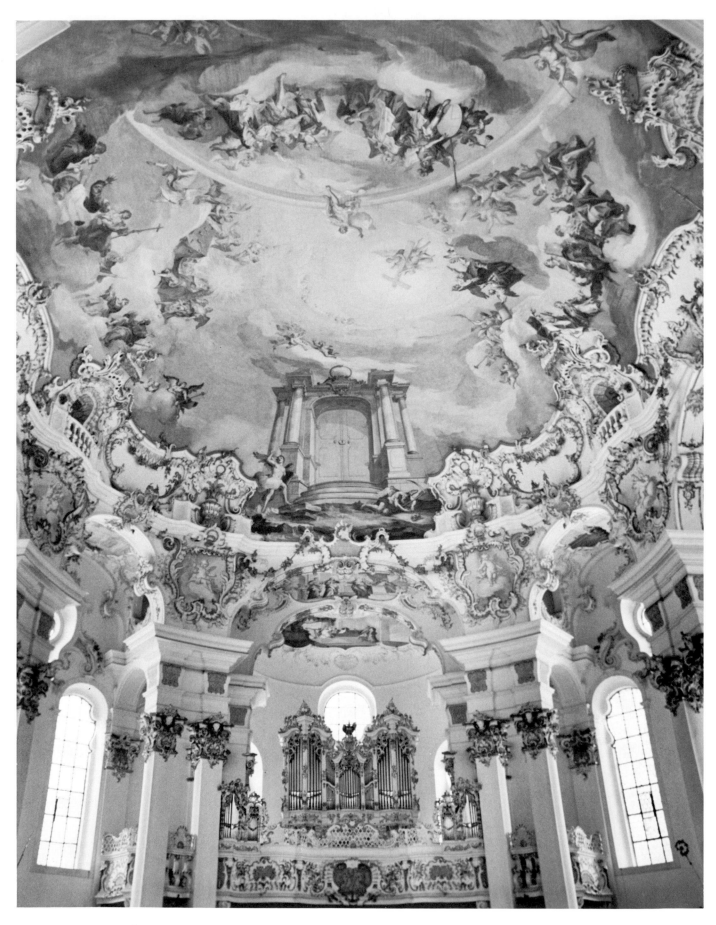

72 Germany: Die Wies (Pilgrimage Church of Christ Scourged), Wies/Steingaden, Bavaria.

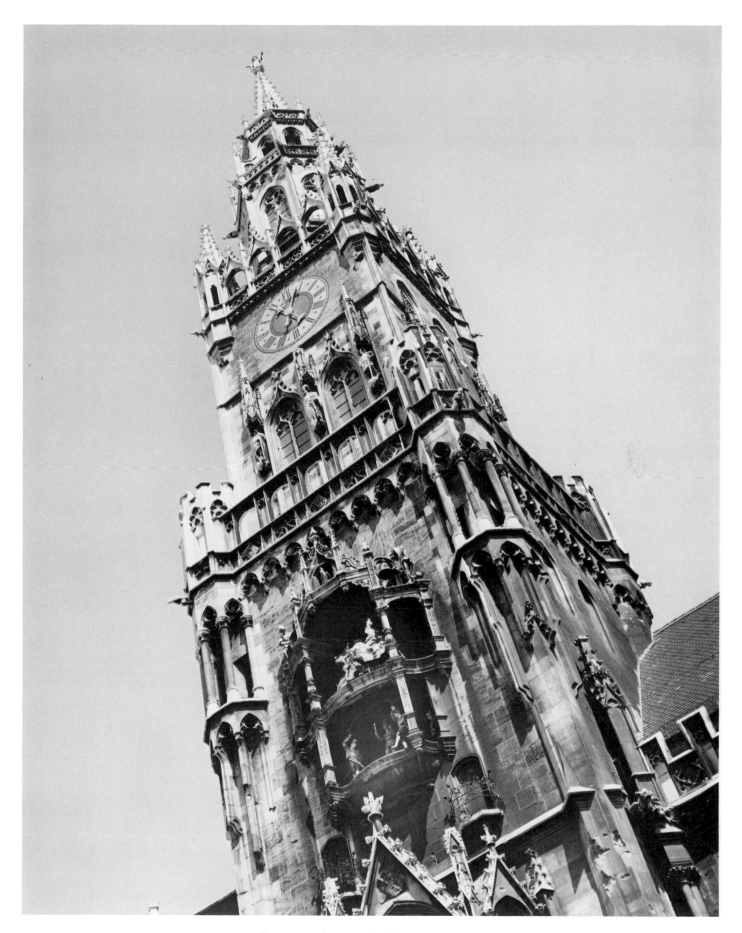

73 Germany: the town hall (Rathaus), Munich.

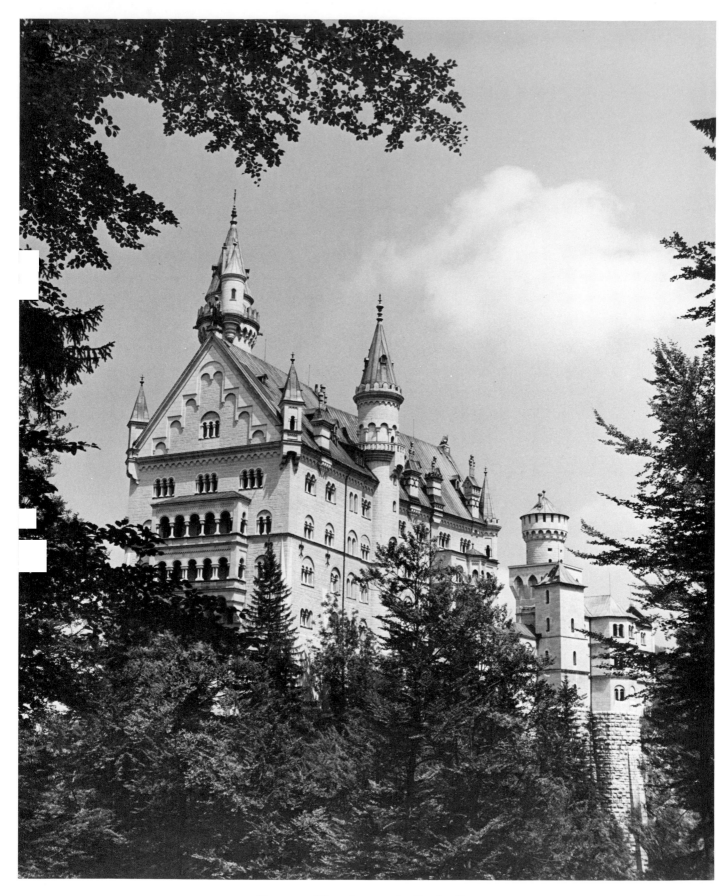

74 Germany: Neuschwanstein Castle, Bavaria.

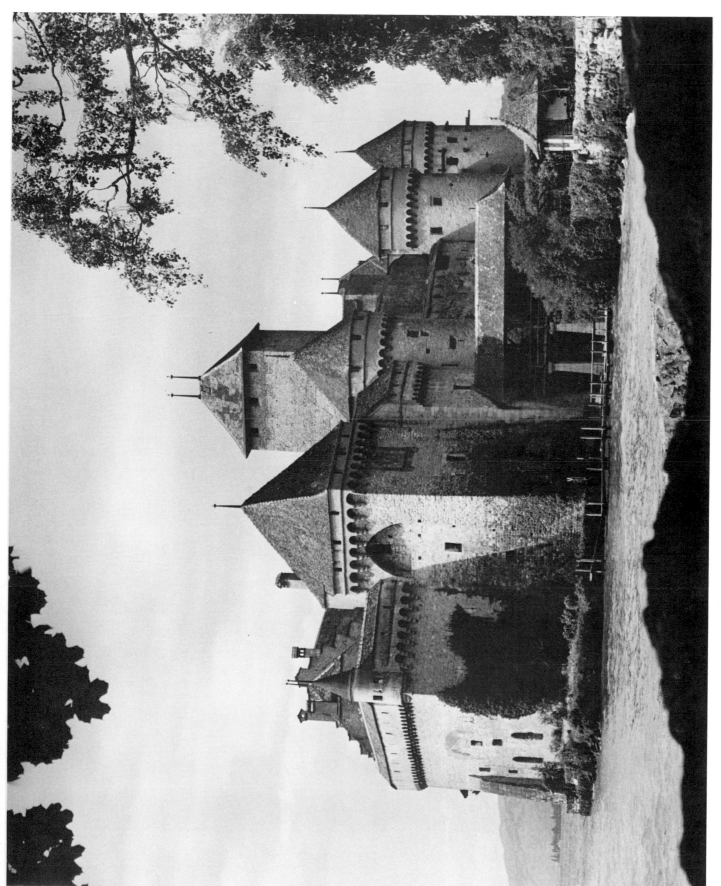

75 Switzerland: the Château de Chillon, on the Lake of Geneva.

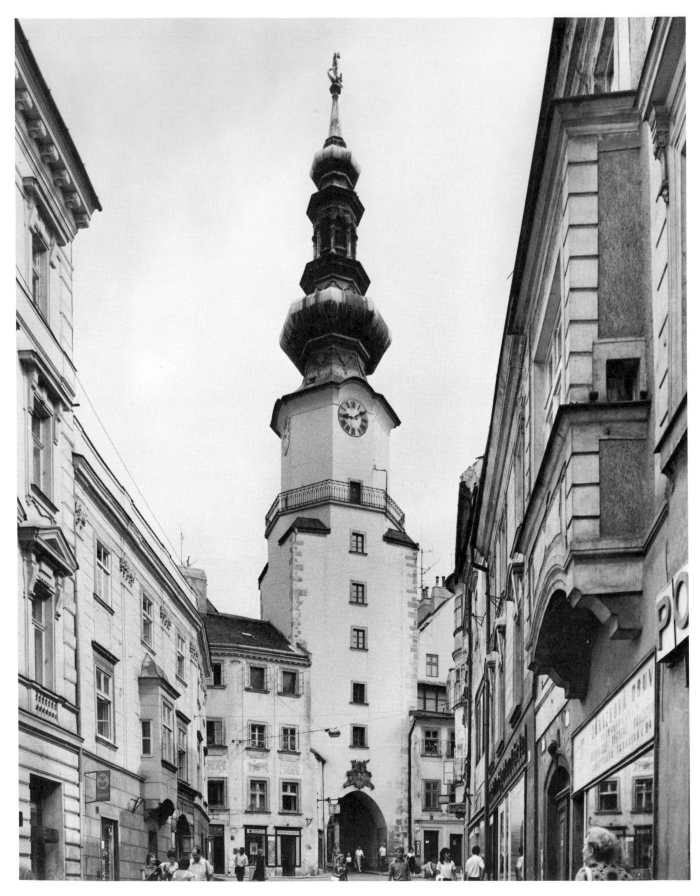

76 Czechoslovakia (Slovakia): St. Michael's Tower, Bratislava.

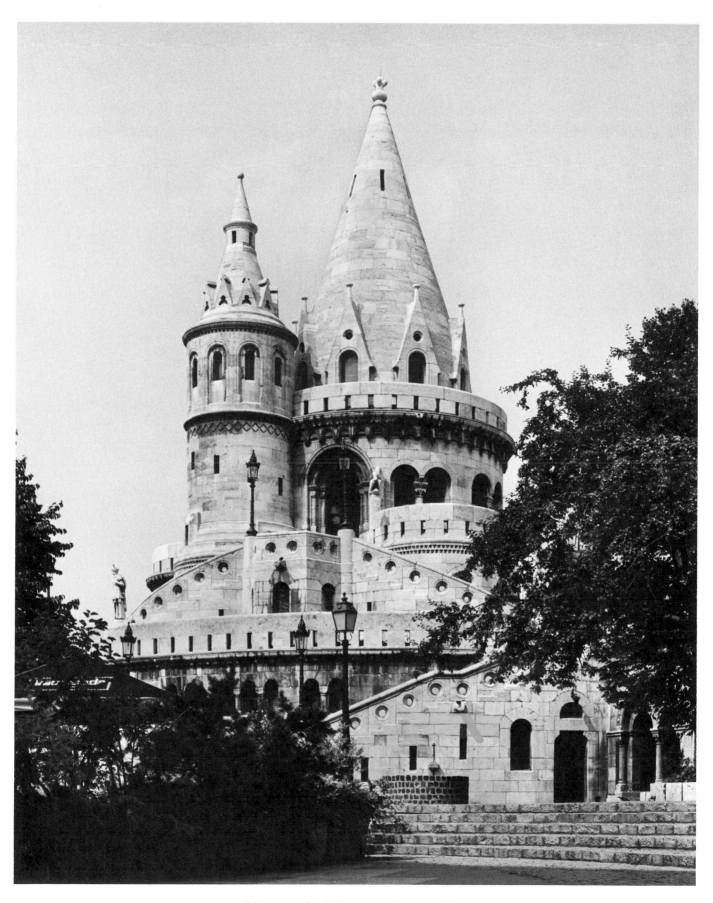

77 Hungary: the Fisherman's Bastion, Budapest.

78 Greece: the Erechtheum, on the Acropolis, Athens.

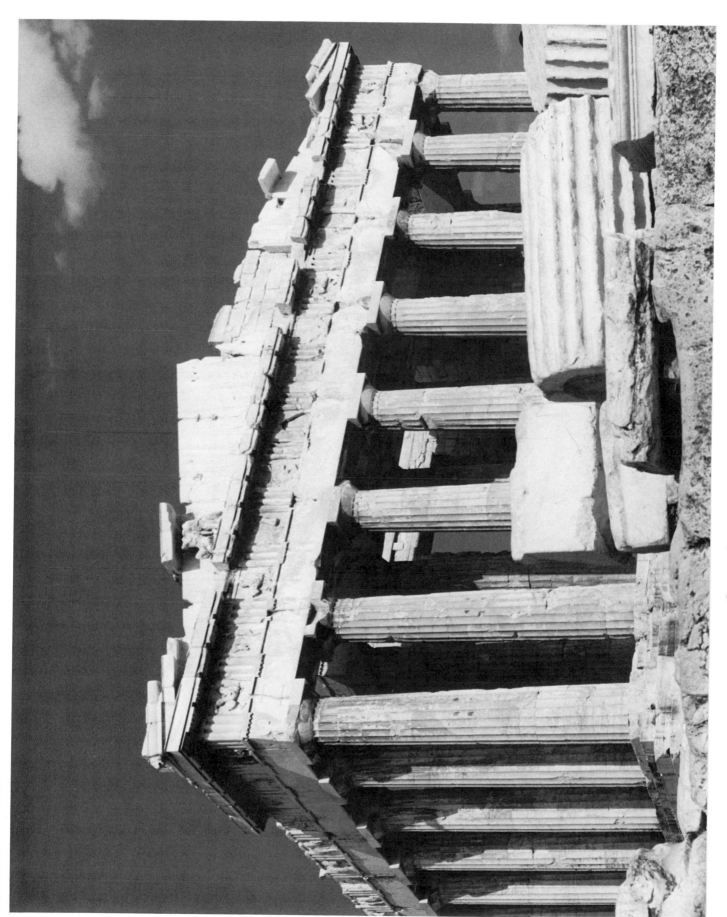

79 Greece: the Parthenon, on the Acropolis, Athens.

80 Greece: theater, Delphi.

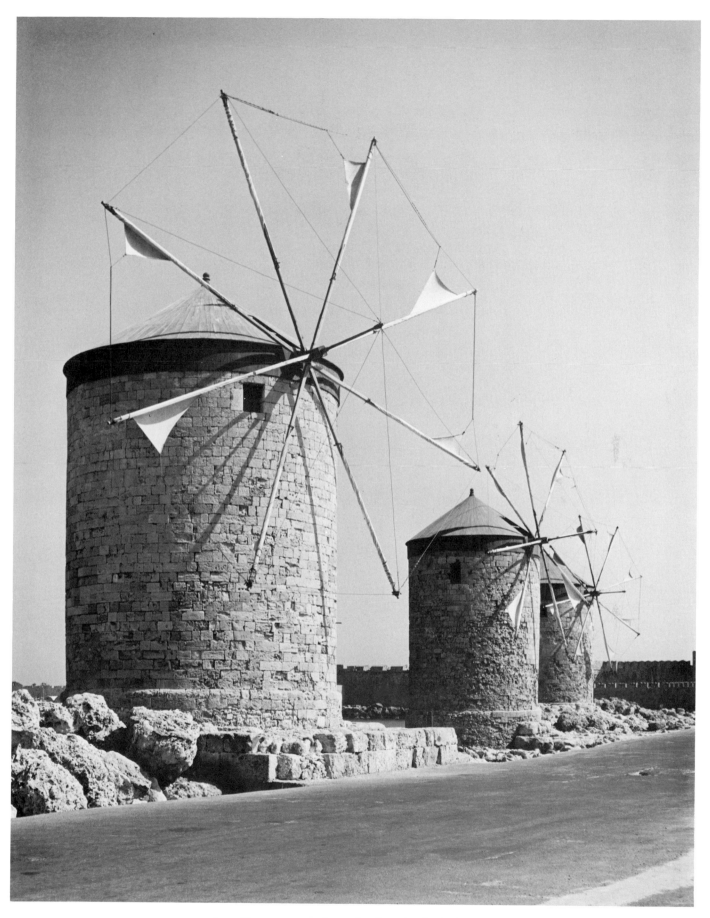

81 Greece: typical windmills, island of Rhodes.

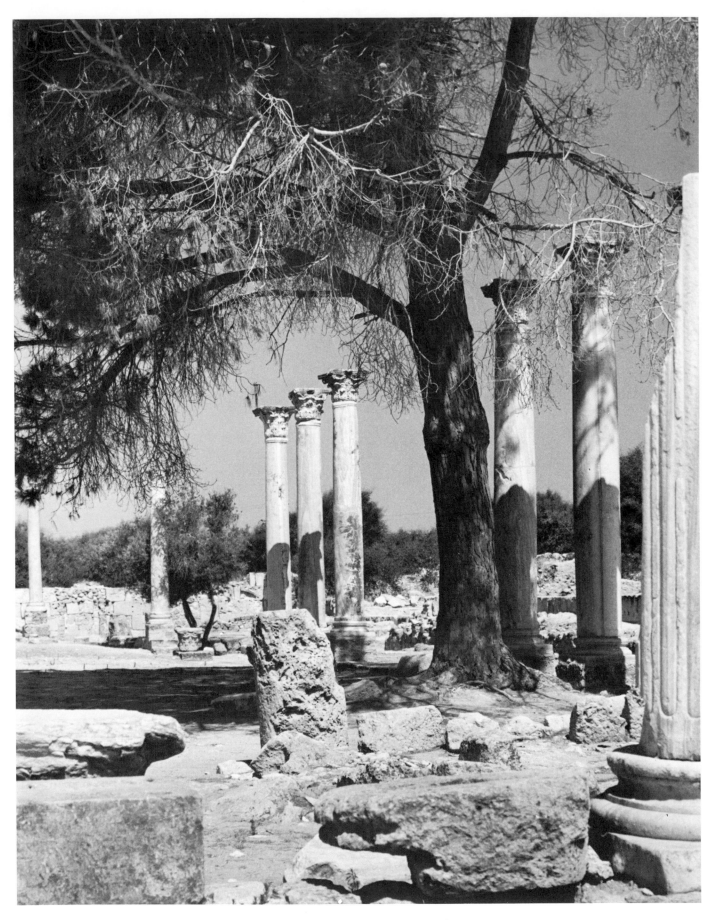

82 Cyprus: Roman-era ruins at Salamis.

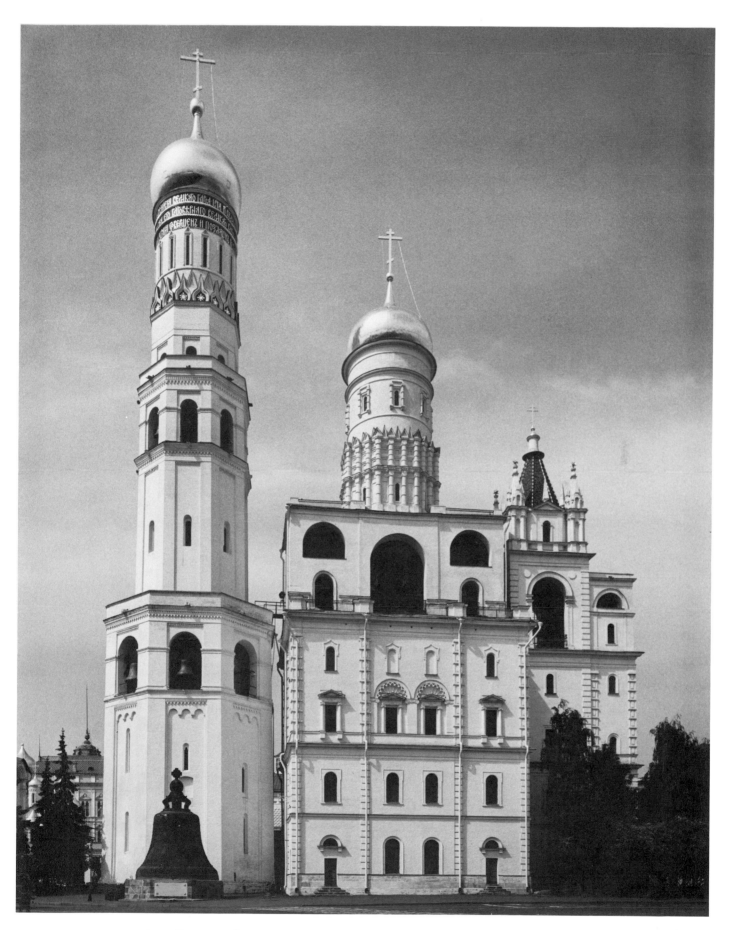

83 Russia: Bell tower of Ivan III and the Tsar Bell, in the Kremlin, Moscow.

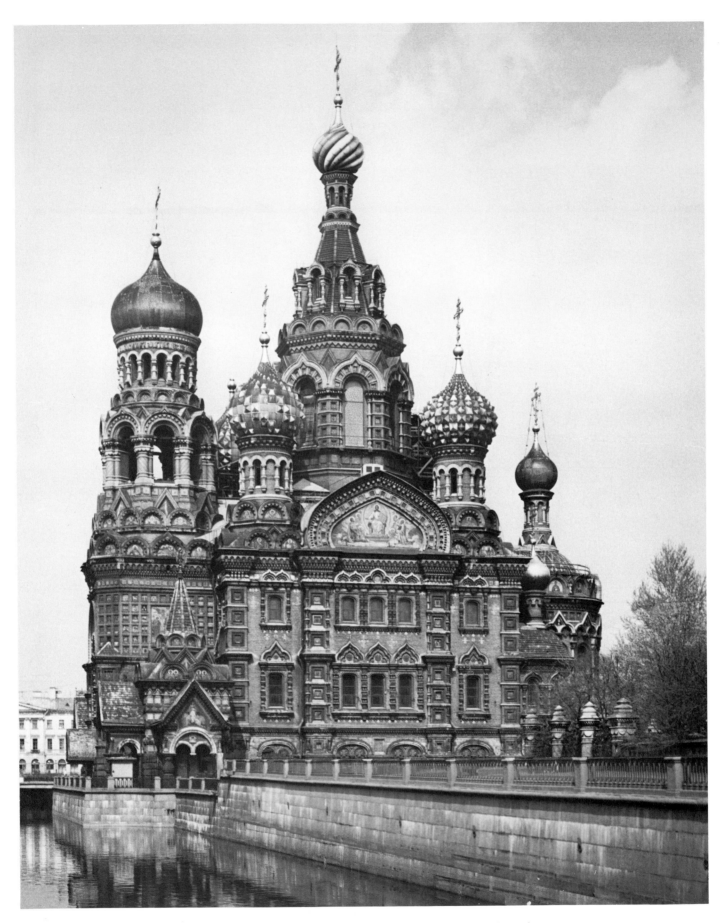

84 Russia: Church of the Resurrection of Christ, St. Petersburg.

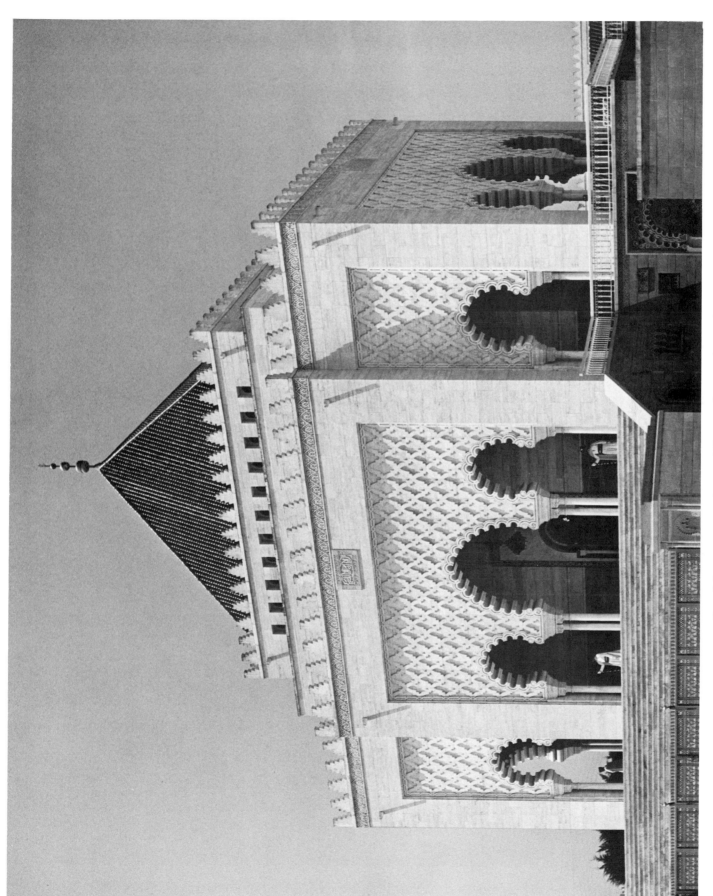

85　Morocco: mausoleum of King Mohammed V, Rabat.

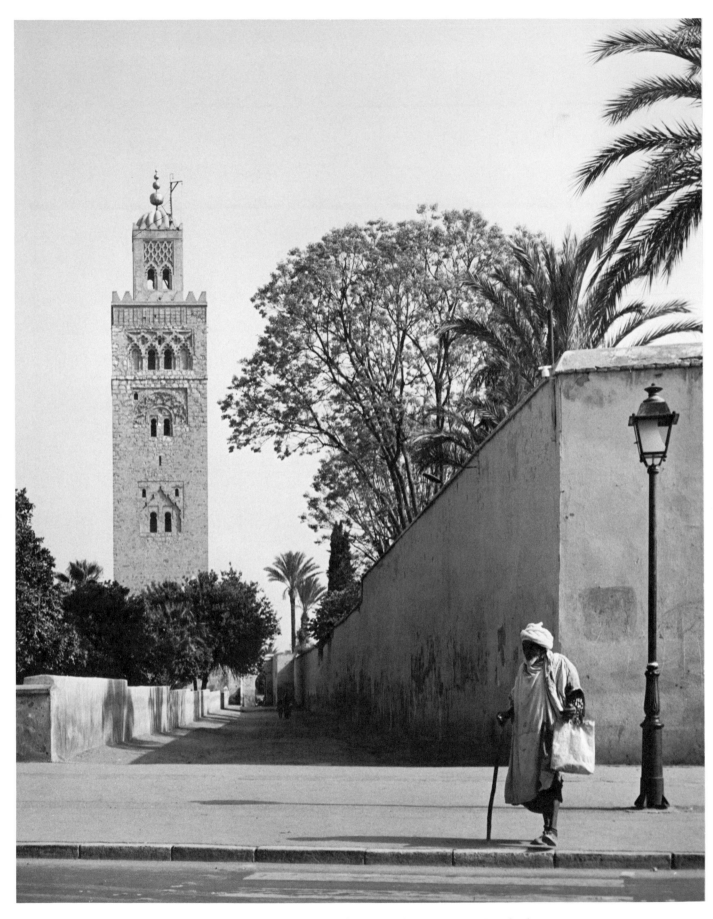

86 Morocco: minaret of the Koutoubia Mosque, Marrakesh.

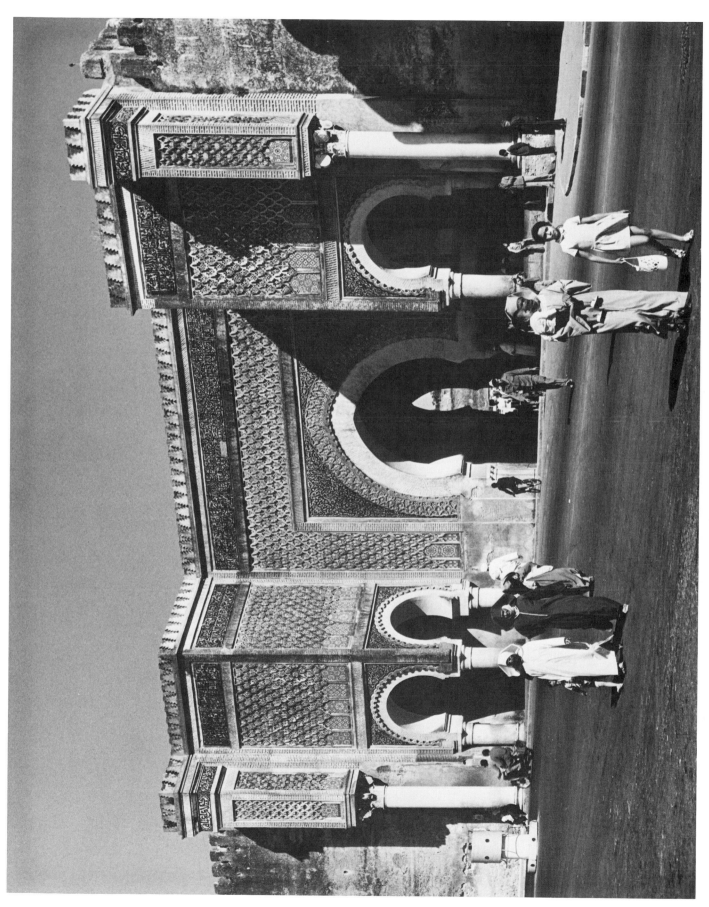

87 Morocco: a medieval gateway.

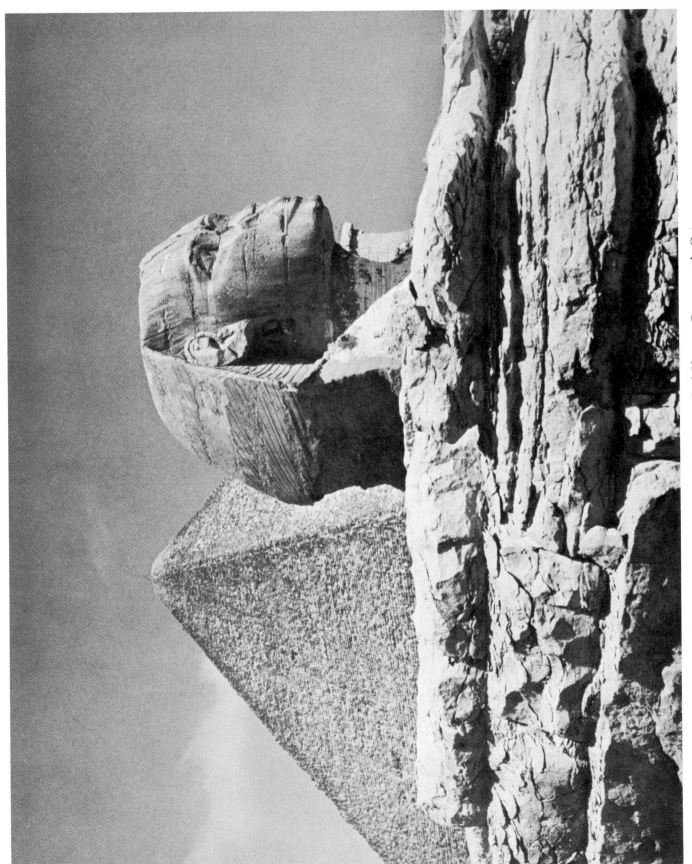

88 Egypt: the Great Sphinx and the Pyramid of Cheops, Giza, outside Cairo.

89 Egypt: the alabaster Sphinx at Memphis.

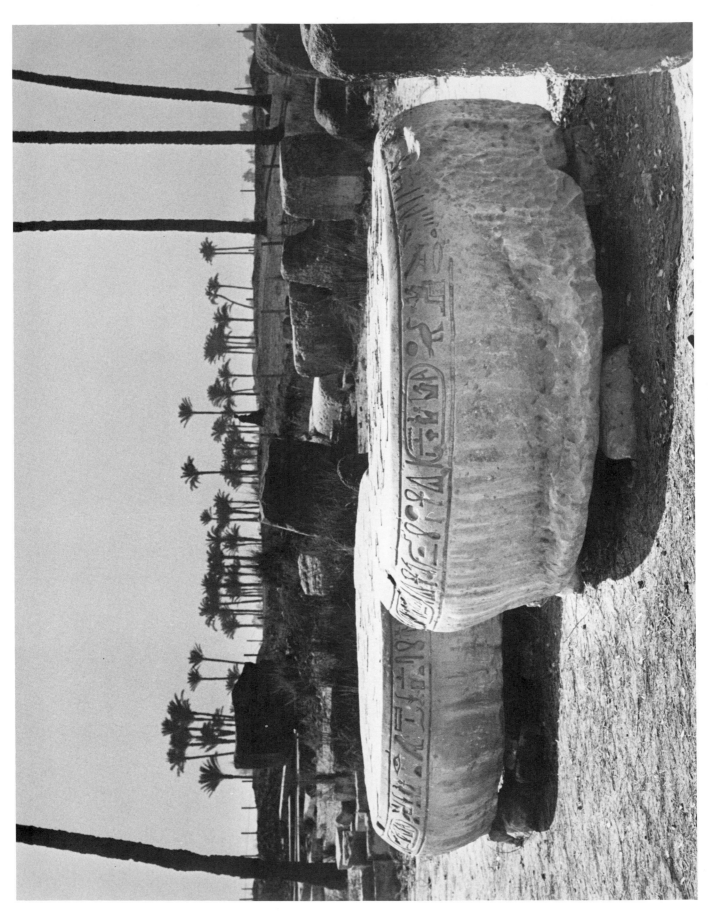

90　Egypt: ancient architectural elements.

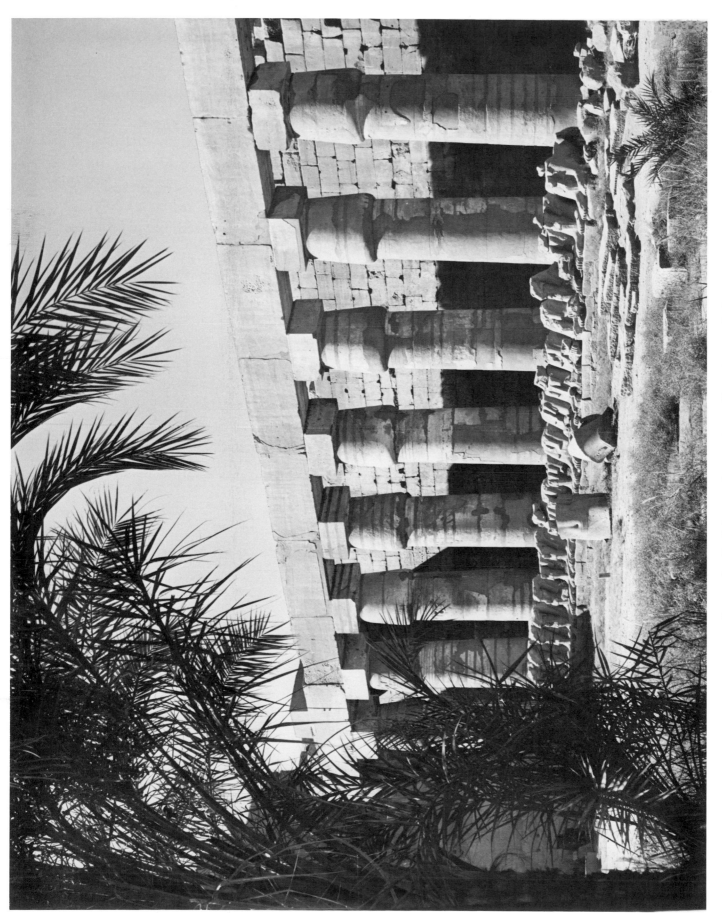

91 Egypt: detail of the temple complex at Karnak, outside Luxor.

92 Egypt: the "Colossi of Memnon," Thebes, near Luxor.

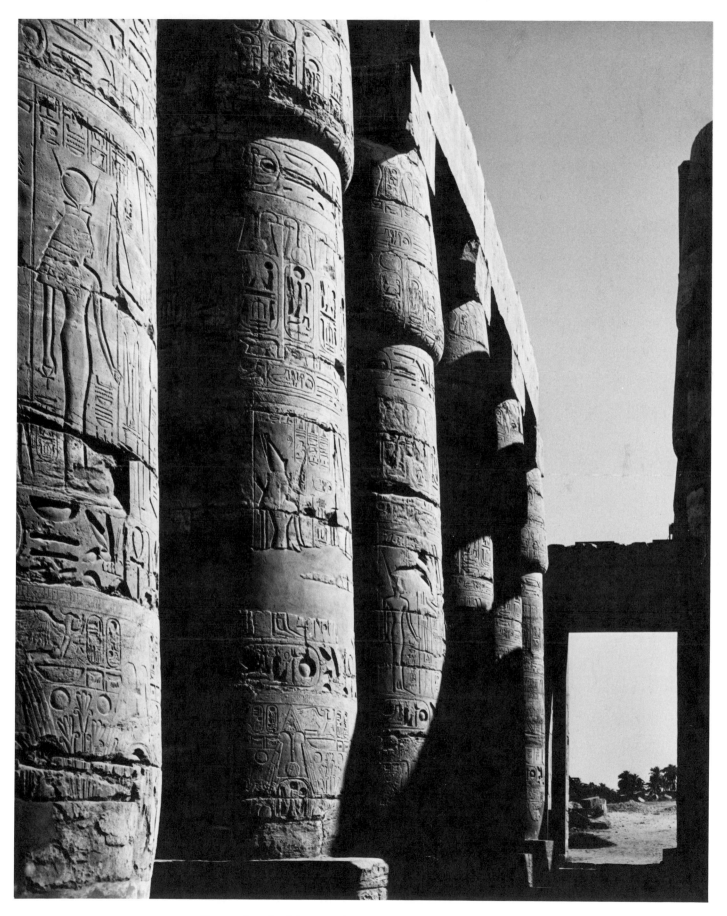

93 Egypt: detail of the temple complex at Karnak, outside Luxor.

94 Lebanon: the harbor in the medieval section of Byblos (Jbail).

95 Turkey: a modern view near the ancient ruins of Ephesus (Efes).

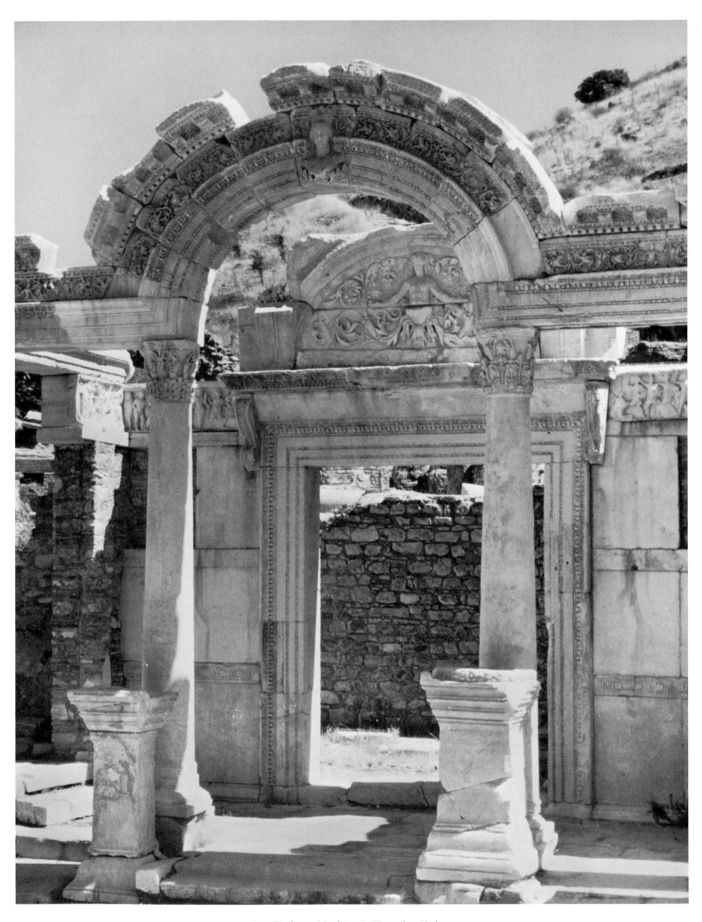

96 Turkey: Hadrian's Temple, Ephesus.

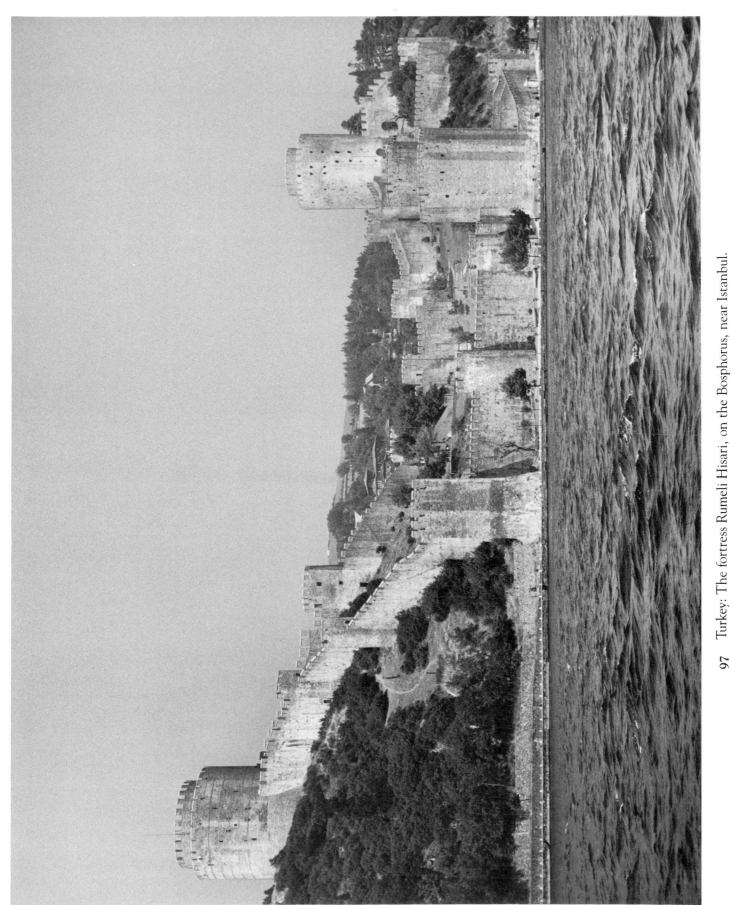

97 Turkey: The fortress Rumeli Hisari, on the Bosphorus, near Istanbul.

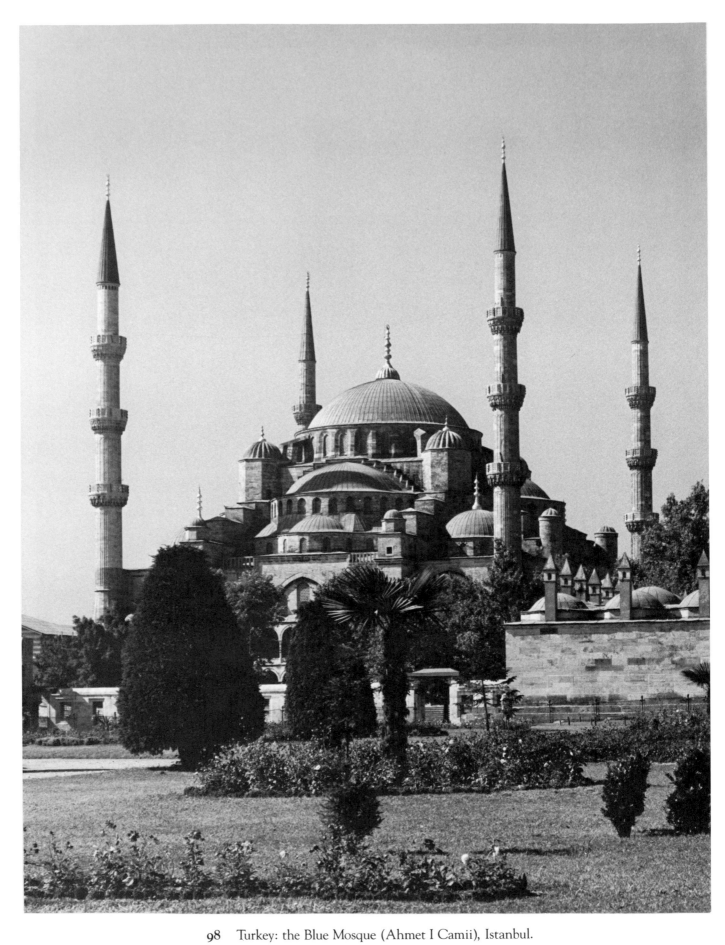

98 Turkey: the Blue Mosque (Ahmet I Camii), Istanbul.

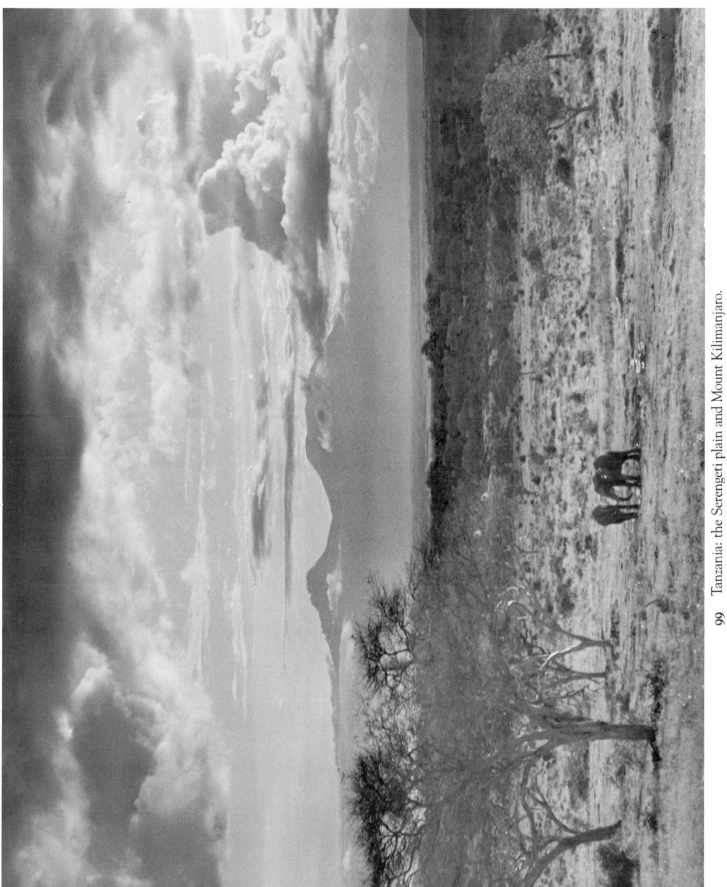

99 Tanzania: the Serengeti plain and Mount Kilimanjaro.

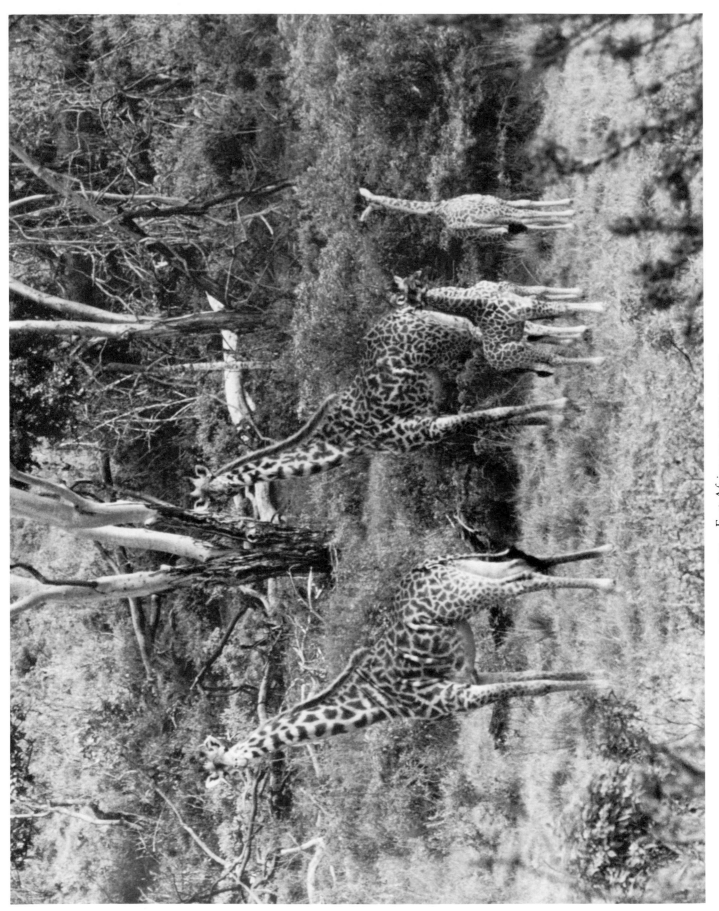

100 East Africa: on a game reserve.

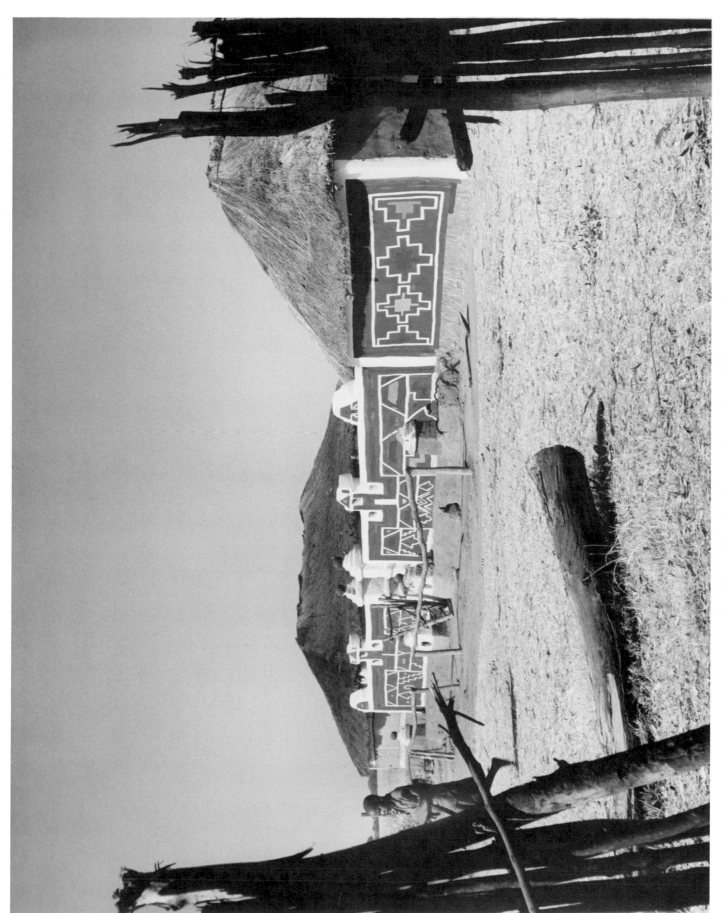

101 Republic of South Africa: a village of the Ndebele people.

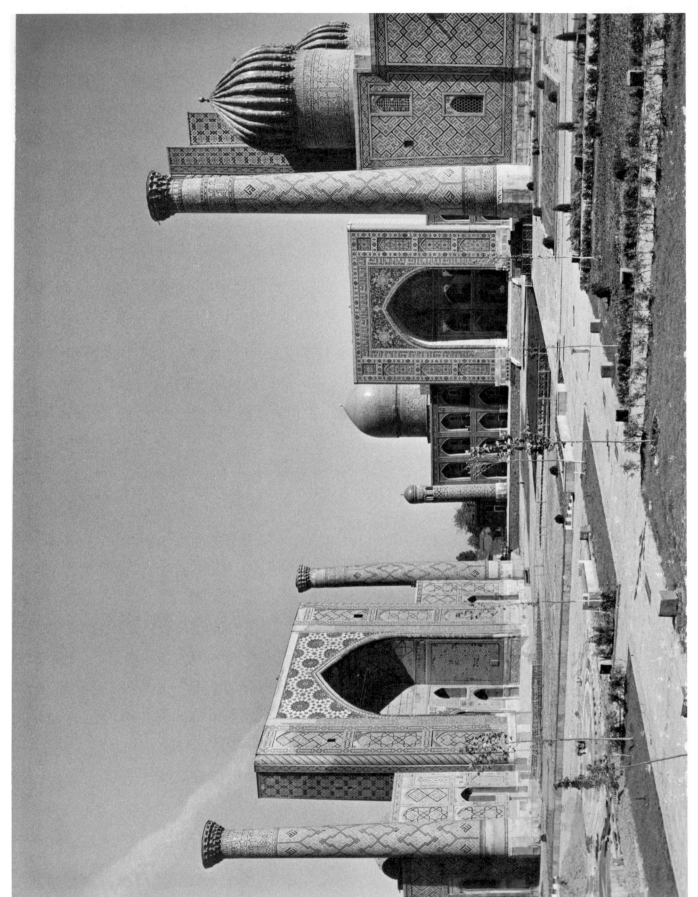

102 Republic of Uzbekistan (former Soviet Union): the Rigestan square in Samarkand, with two of the three old theological schools that surround it on three sides.

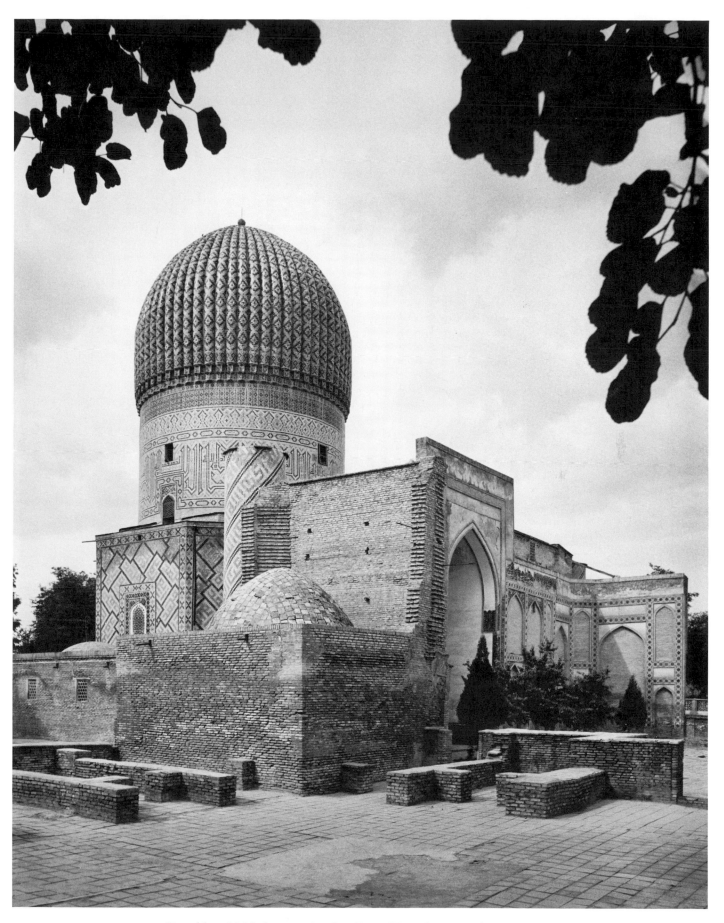

103 Republic of Uzbekistan: the Gur Emir (Tamerlane's tomb) in Samarkand.

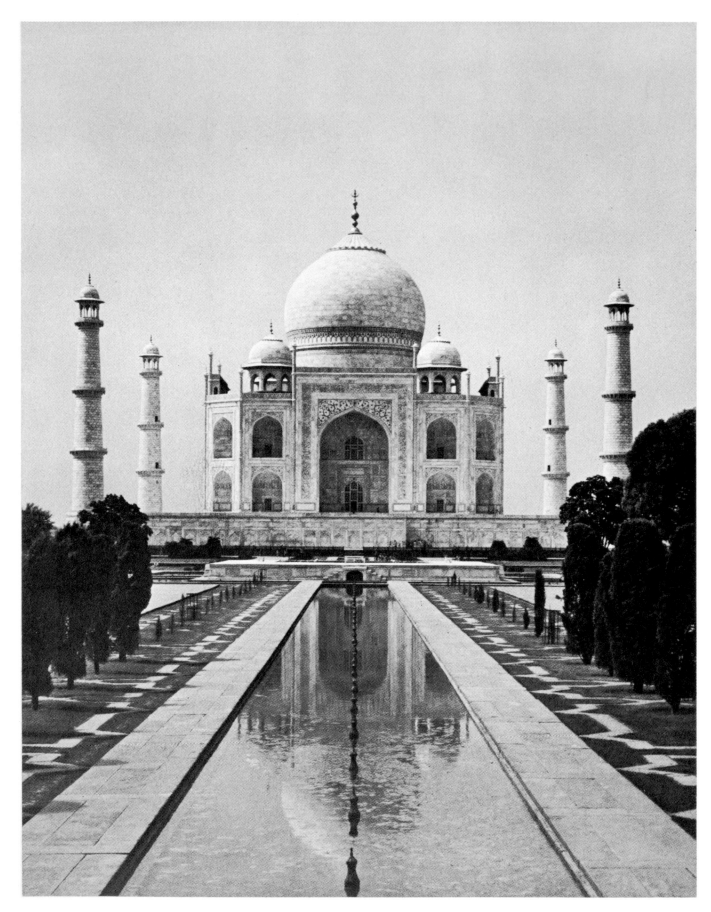

104 India: The Taj Mahal at Agra.

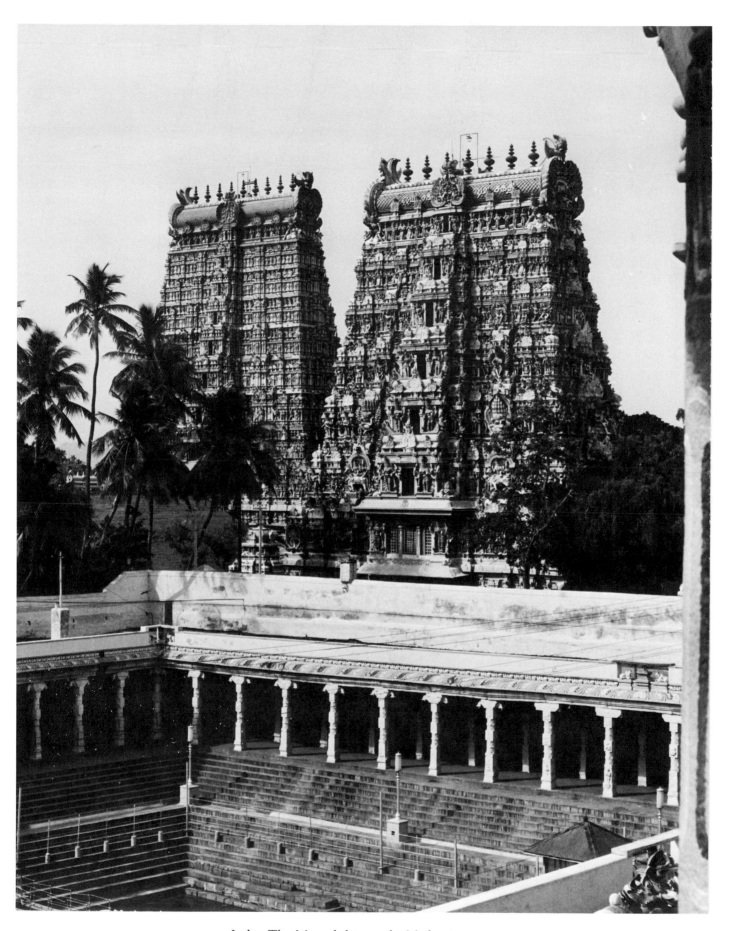

105 India: The Meenakshi temple, Madurai.

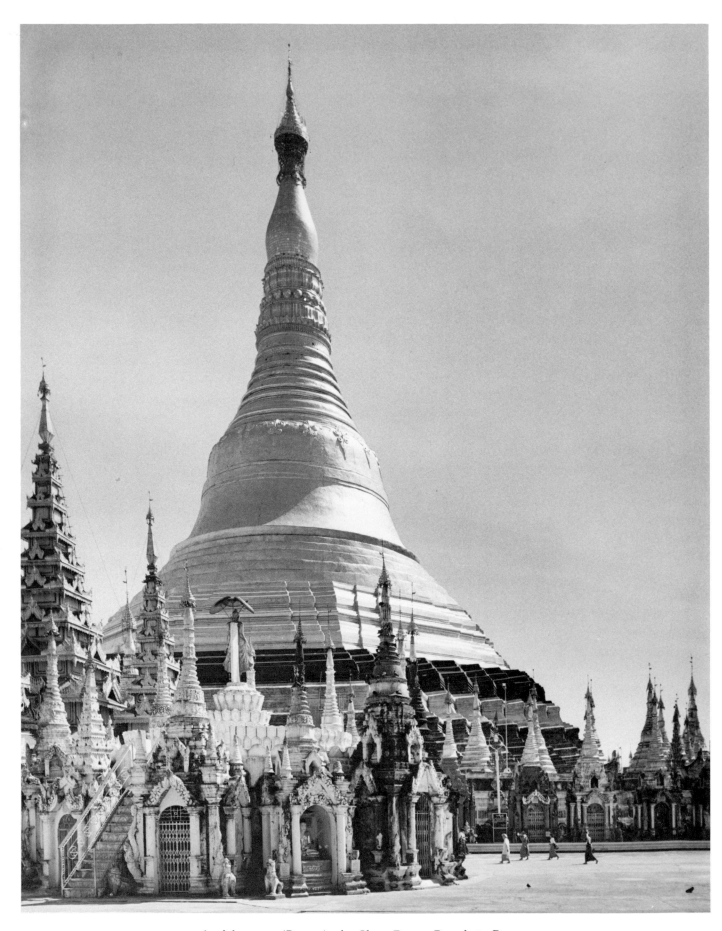

106 Myanmar (Burma): the Shwe Dagon Pagoda in Rangoon.

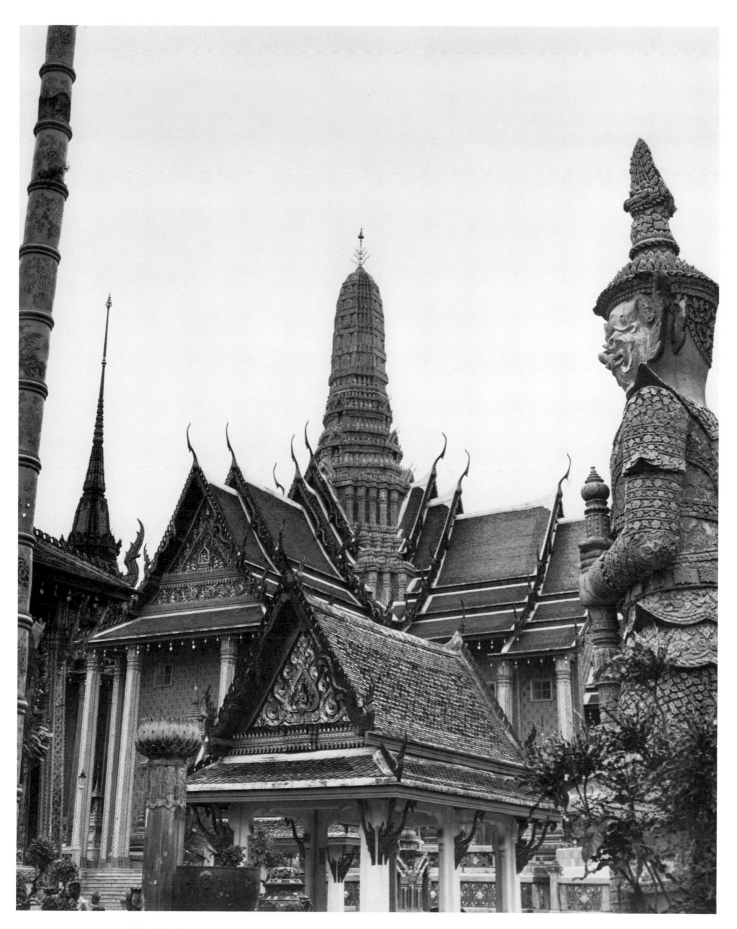

107 Thailand: part of the grounds of Wat Phra Kaeo (Emerald Buddha Temple) in Bangkok.

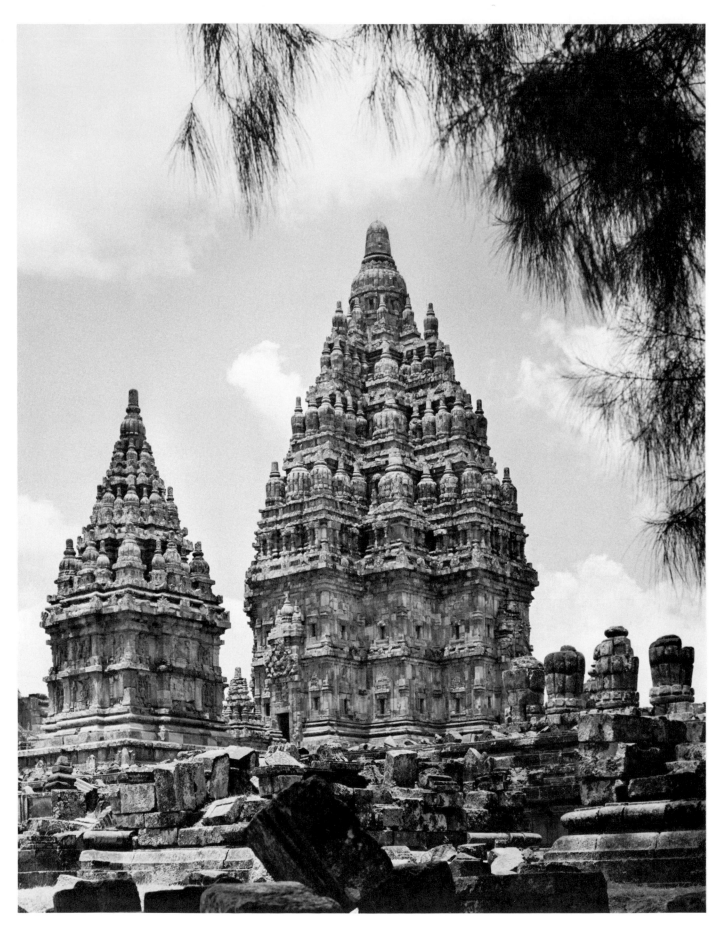

108 Indonesia: the Hindu temple complex at Prambanan, Java.

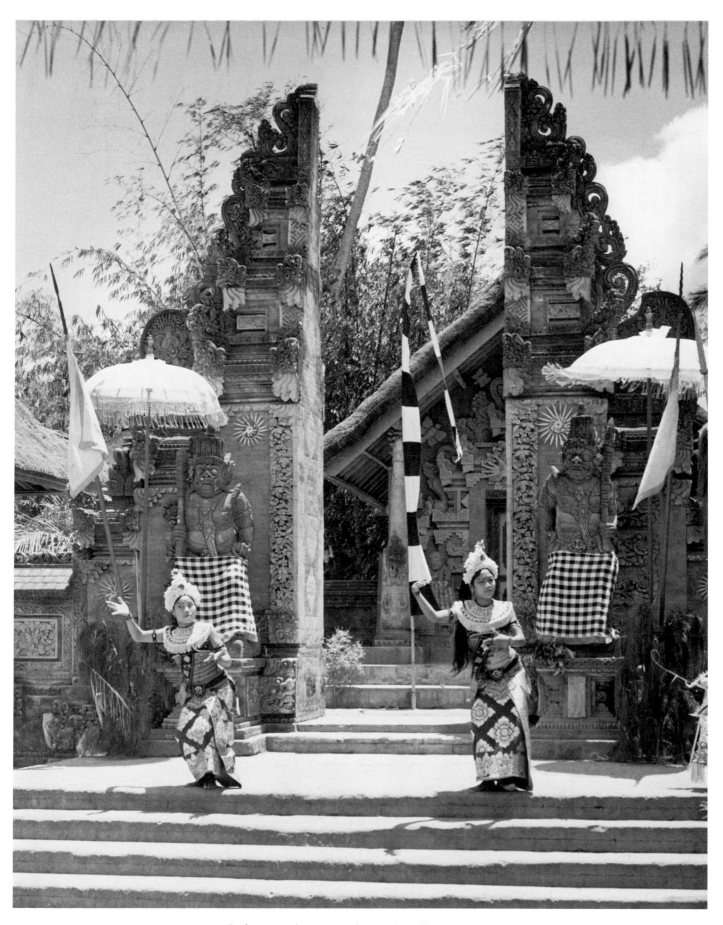

109 Indonesia: dancers in front of a village temple, Bali.

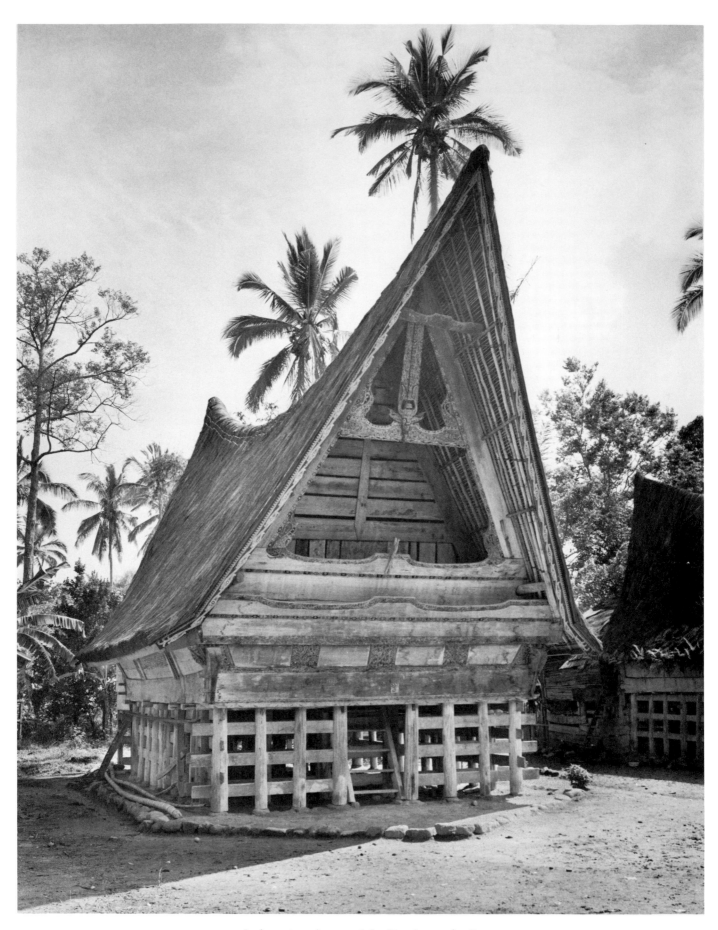

110 Indonesia: a house of the Batak people, Sumatra.

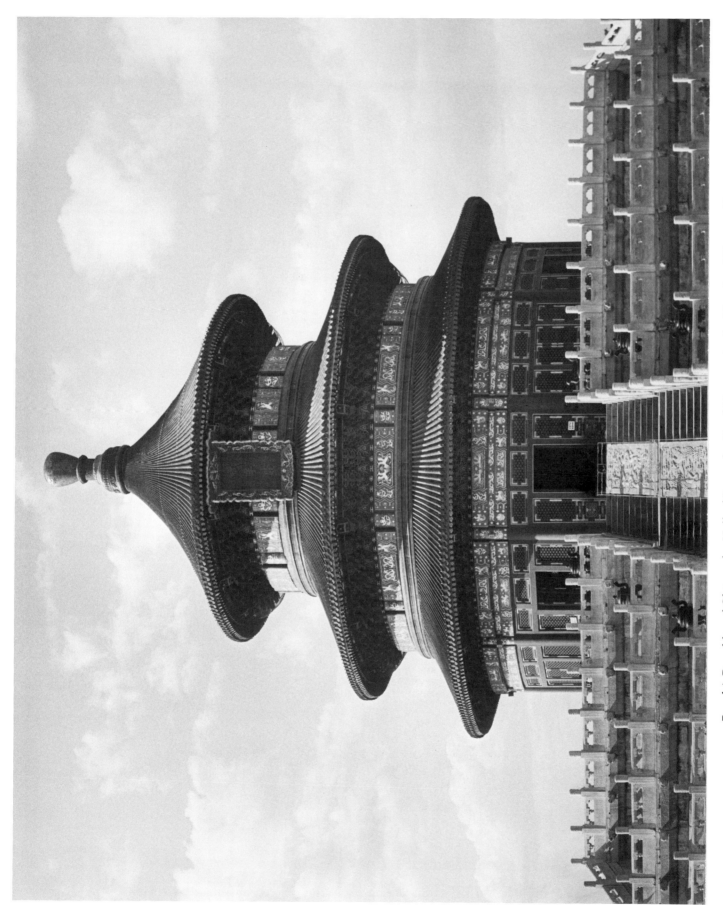

111 People's Republic of China: the Hall of Prayer for Good Harvests in the Temple of Heaven, Beijing.

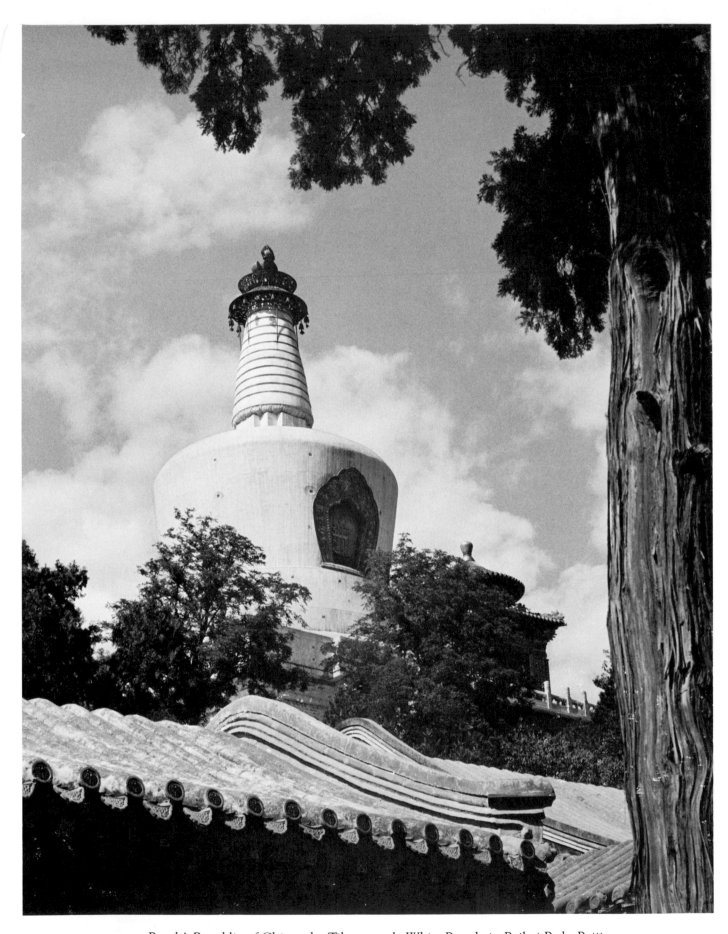

112 People's Republic of China: the Tibetan-style White Pagoda in Beihai Park, Beijing.

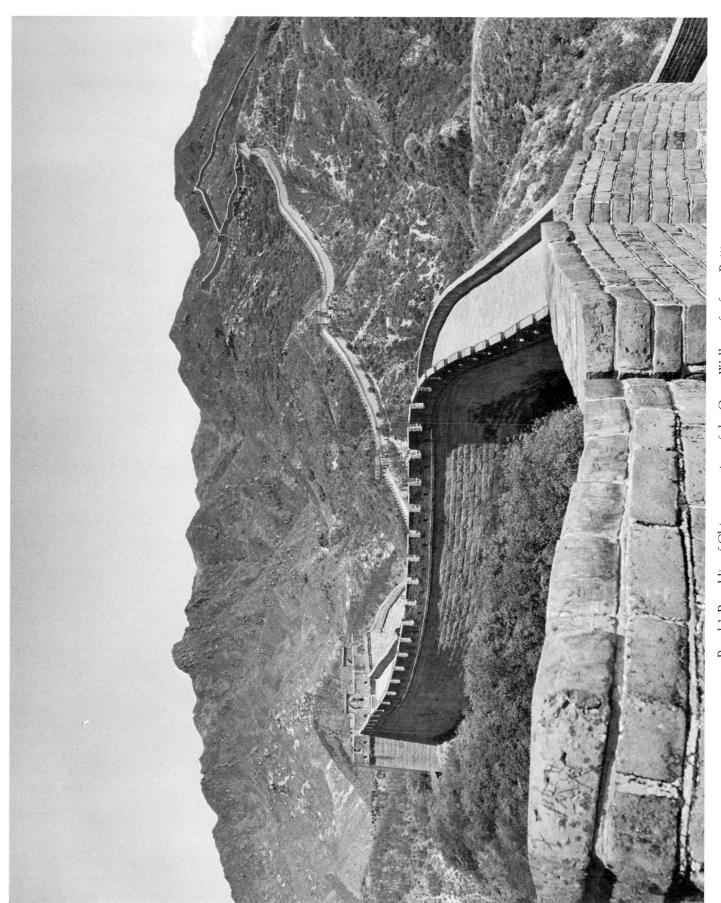

113 People's Republic of China: a section of the Great Wall not far from Beijing.

114 People's Republic of China: dragon decoration on a wall.

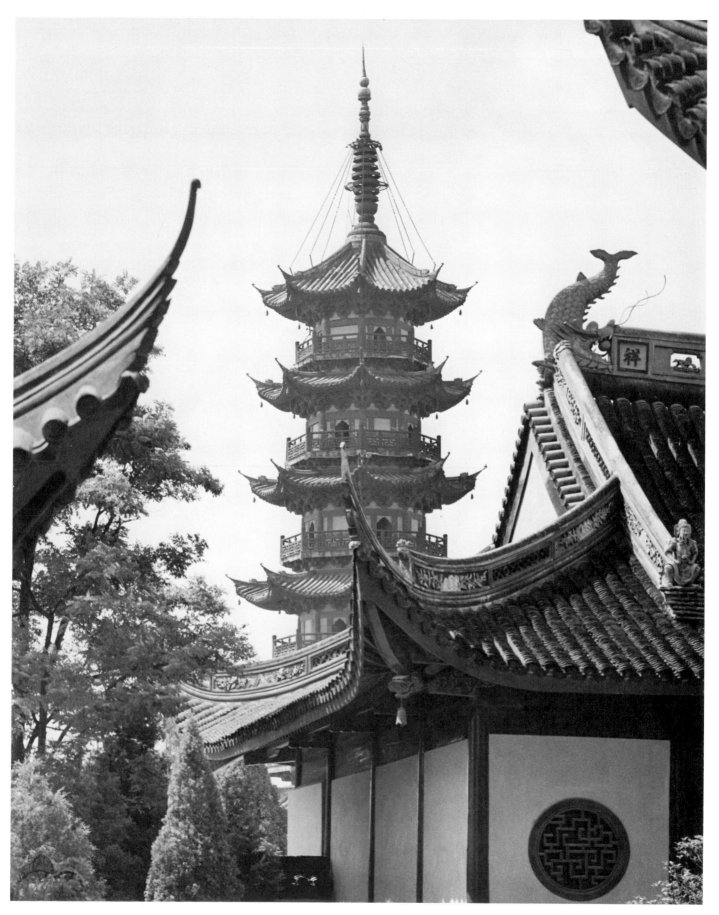

115 People's Republic of China: Longhua Pagoda, Shanghai.

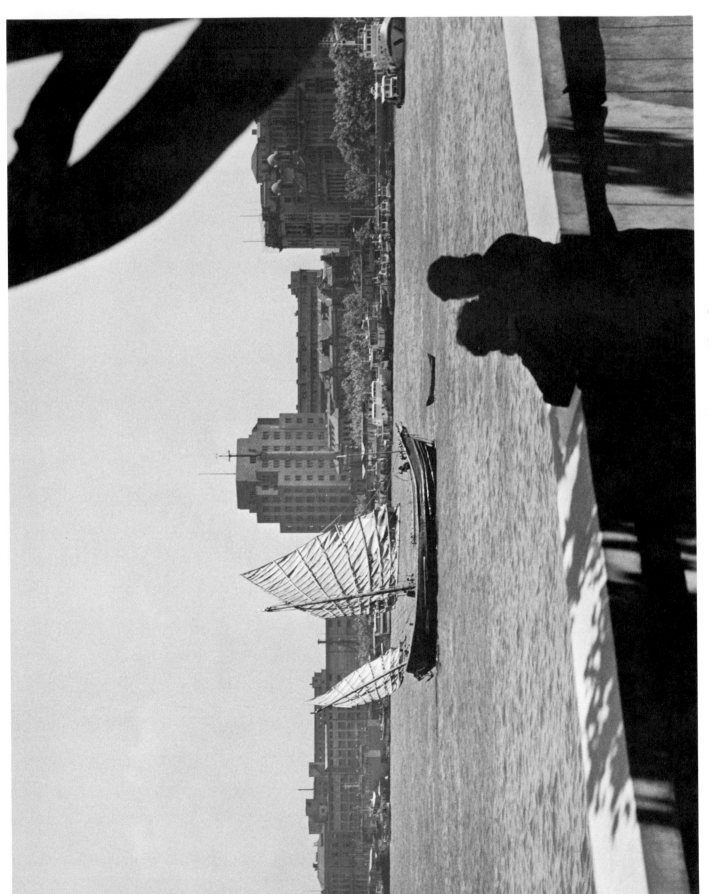

116 People's Republic of China: harbor scene, Shanghai.

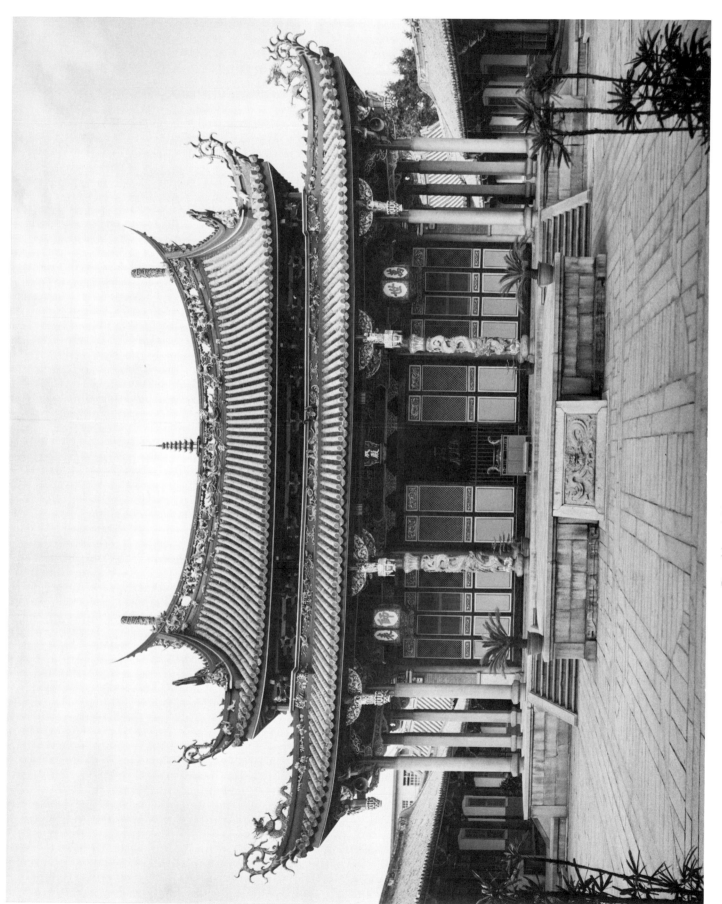

117 Republic of China (Taiwan): A temple in Taipei.

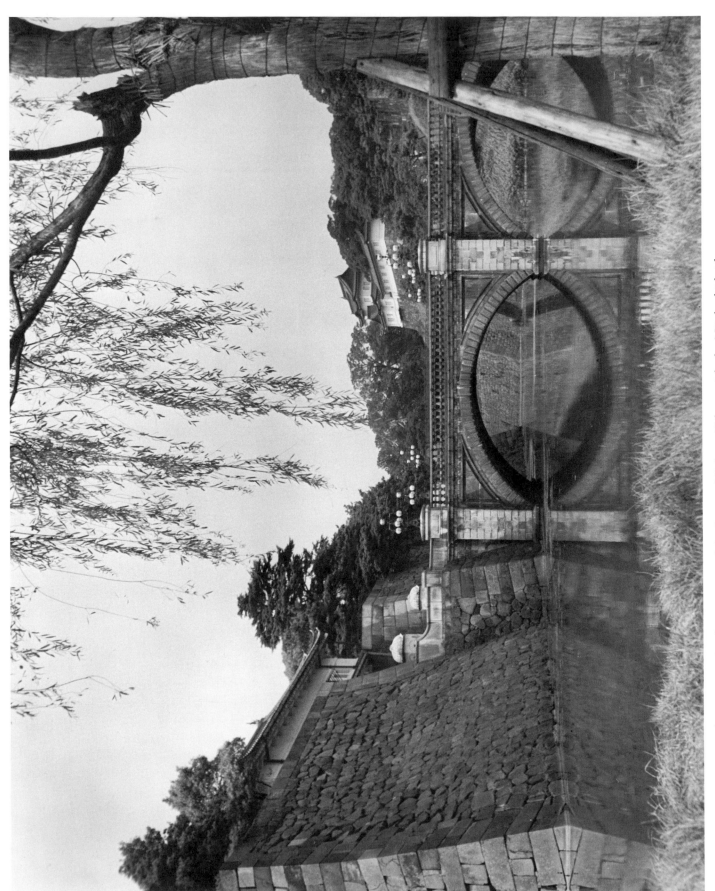

118 Japan: moat of the Imperial Palace, Tokyo, with the Nijubashi bridge.

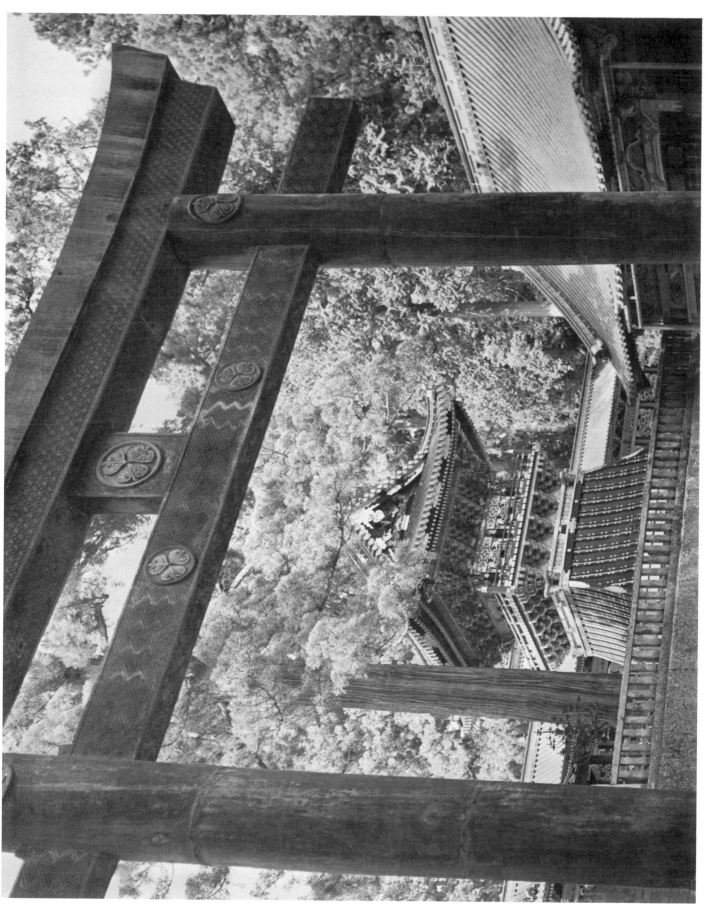

119 Japan: a Shinto shrine.

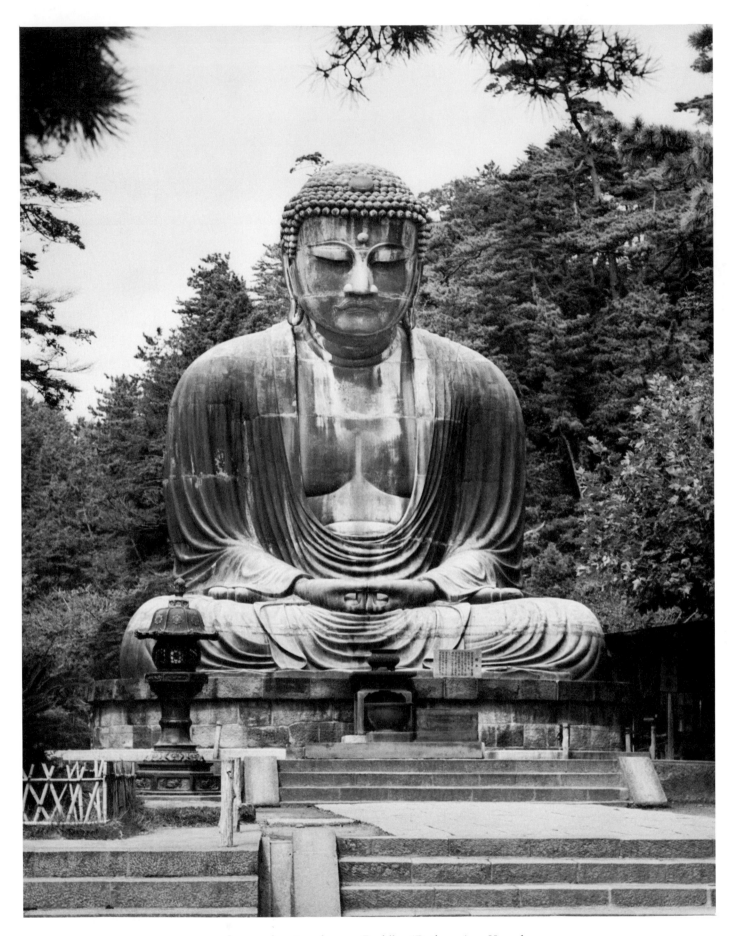

120 Japan: the giant bronze Buddha (Daibutsu) at Kamakura.

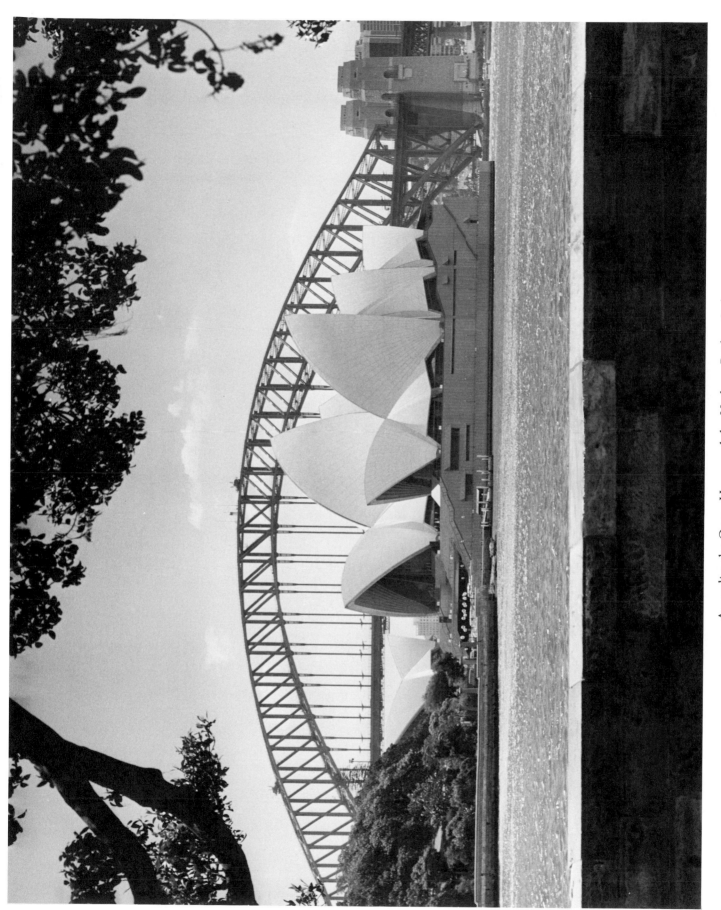

121 Australia: the Opera House and the Harbour Bridge, Sydney.

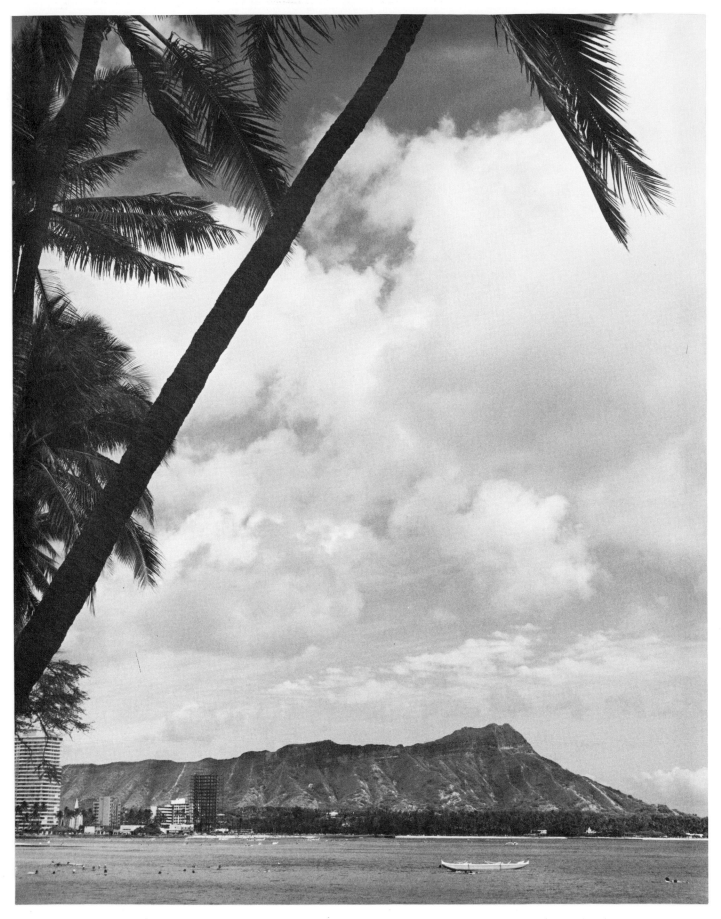

122 Hawaii (United States): Diamond Head at Waikiki Beach, Honolulu, island of Oahu.